Living Spain

Barbara and Jack Wolf

authorHOUSE®

AuthorHouse™
1663 Liberty Drive
Bloomington, IN 47403
www.authorhouse.com
Phone: 1 (800) 839-8640

Published by AuthorHouse 09/10/2016

ISBN: 978-1-5246-3897-9 (sc)
ISBN: 978-1-5246-3896-2 (e)

Library of Congress Control Number: 2016914838

Print information available on the last page.

Thank you to Robert Ziefel.

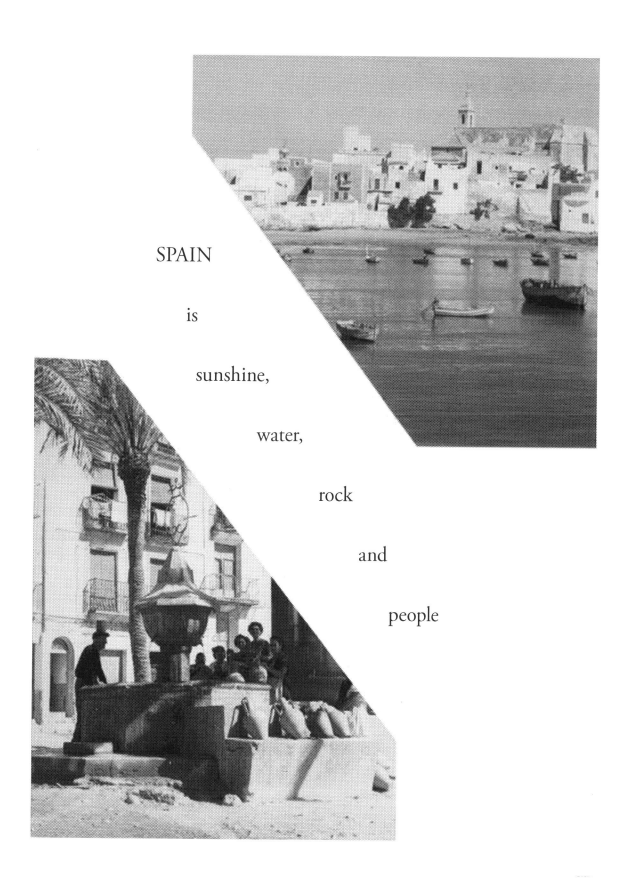

SPAIN

is

sunshine,

water,

rock

and

people

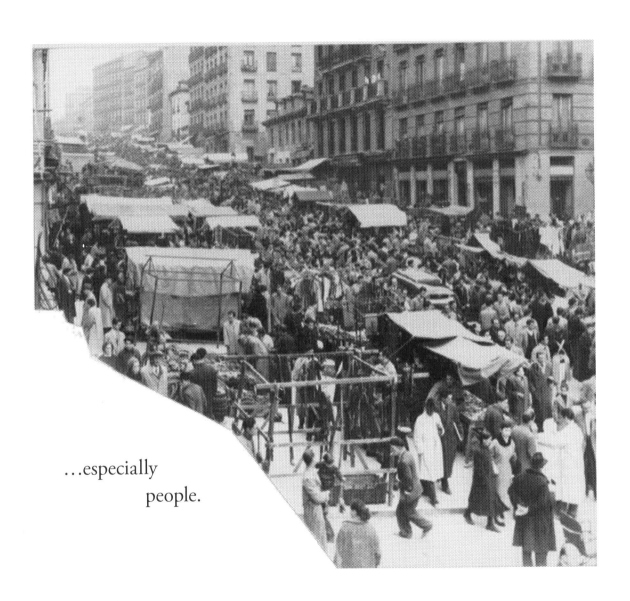

…especially
 people.

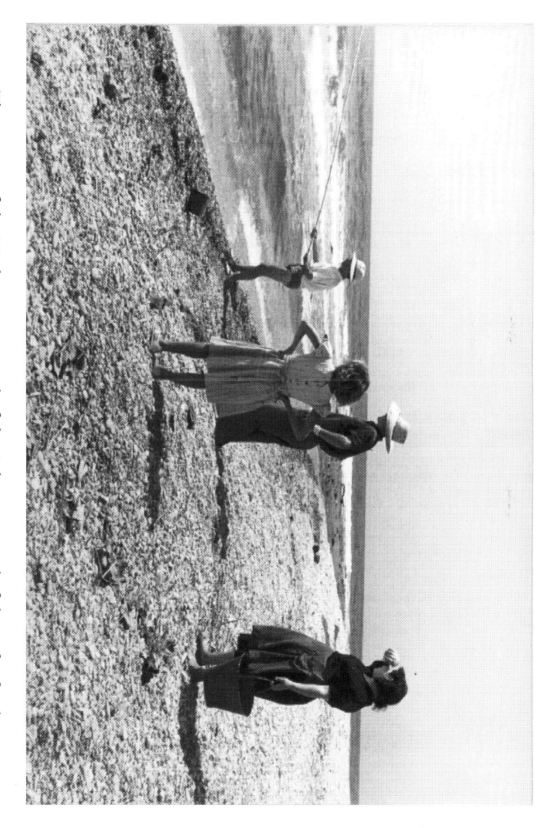

The waters of the Mediterranean and of the Atlantic provide fishing for food…

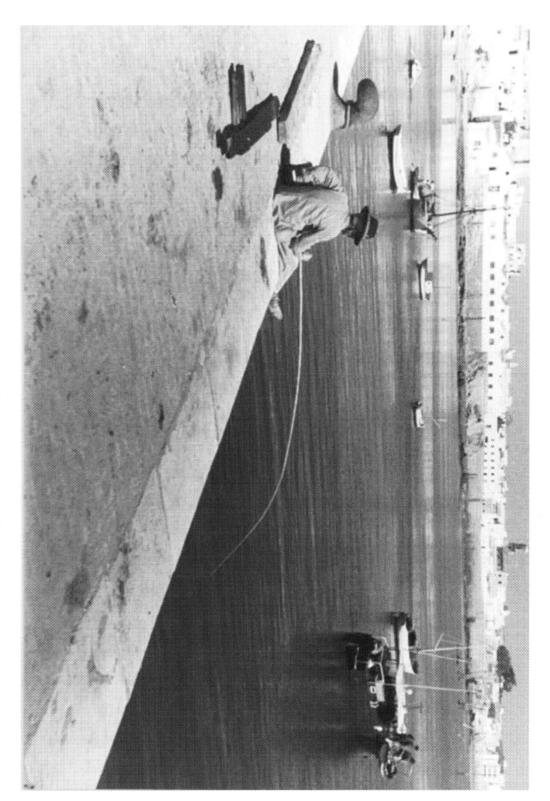

...personal enjoyment and solitude or...

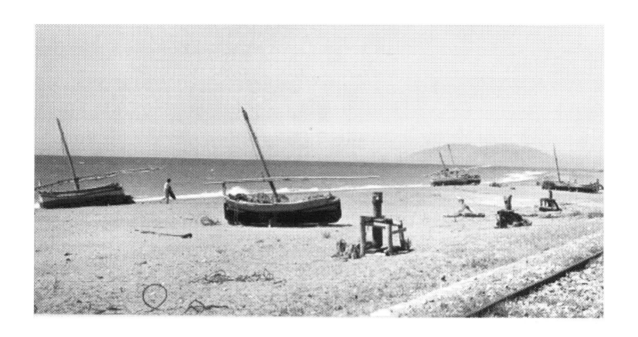

...more commercially by net and boat.

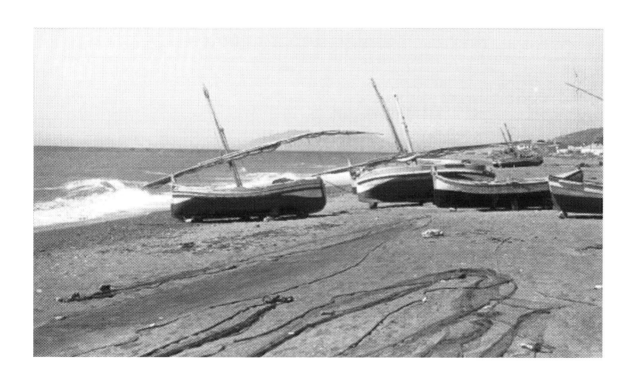

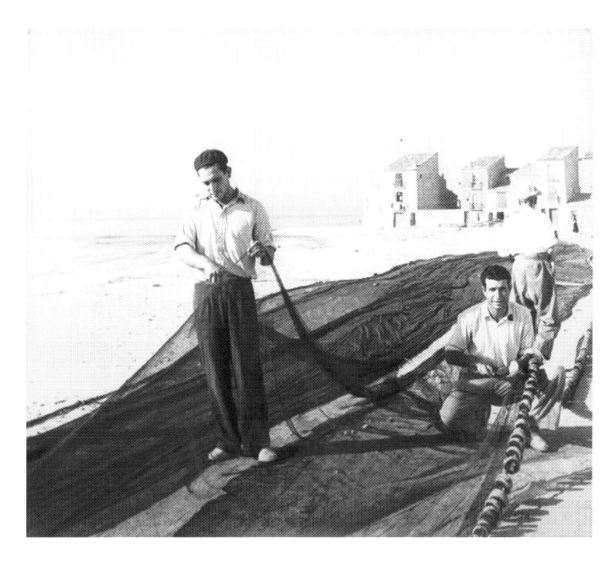

Fishing is a community affair involving families and often a whole village...

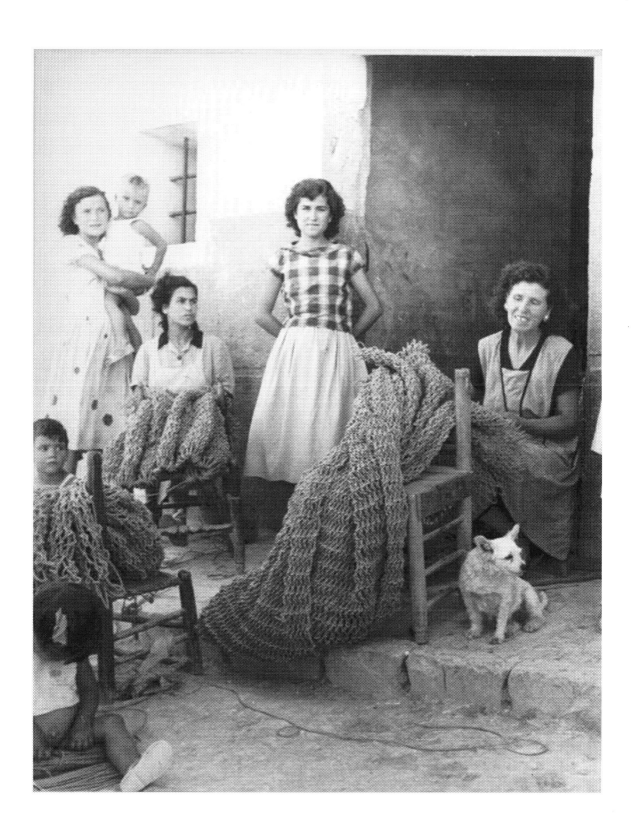

...while the children...

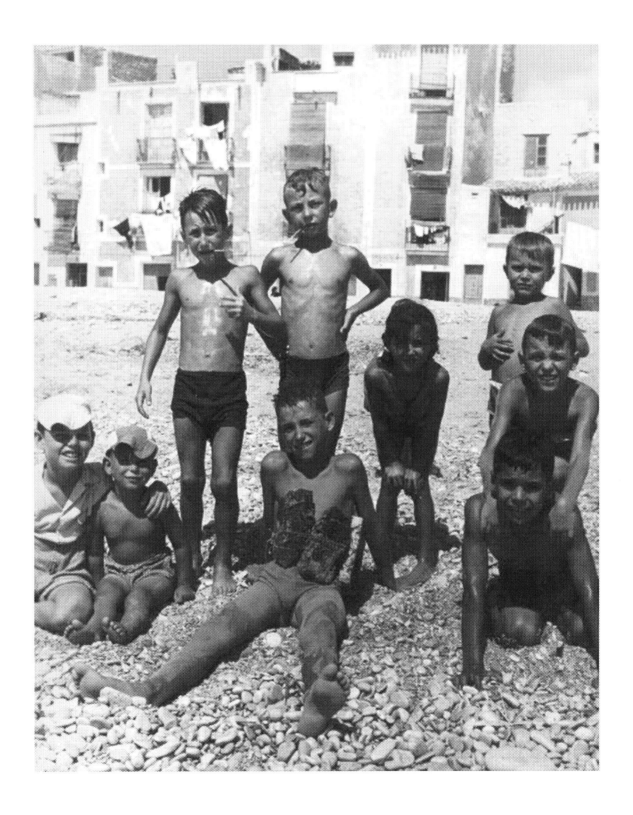

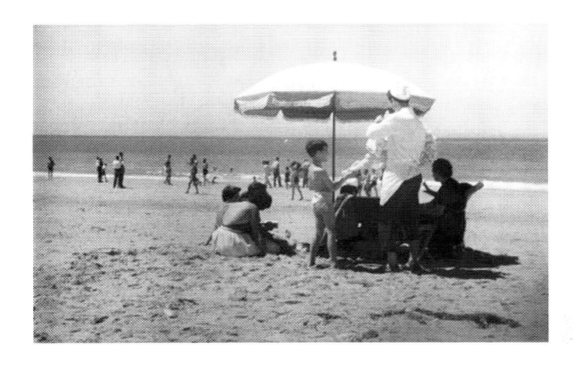

...and vacationers find their own uses
for the sea.

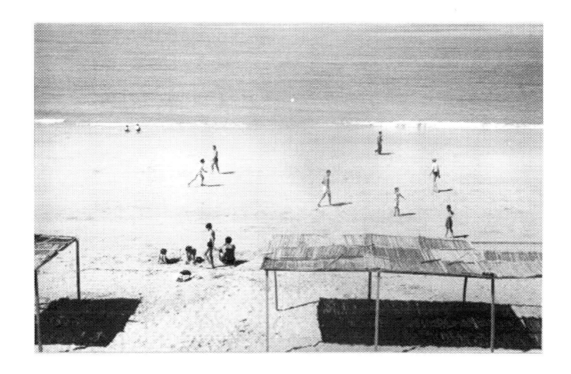

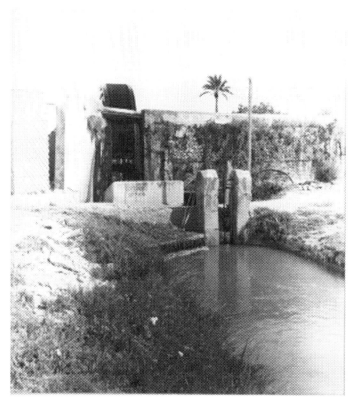

Inland waterways

bring life to the soil...

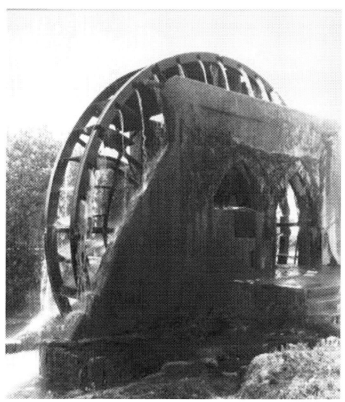

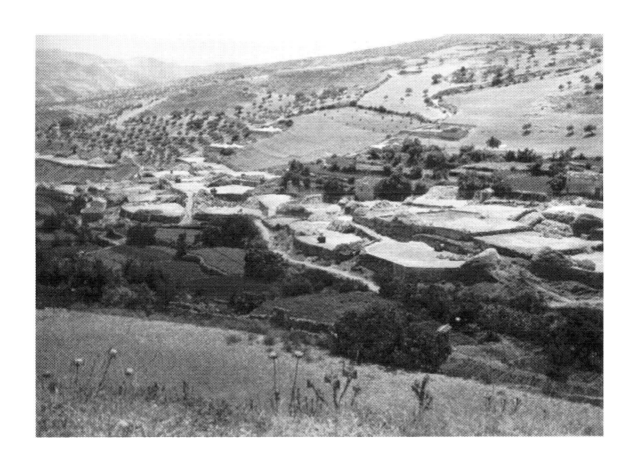

...for trees...

...and fields...

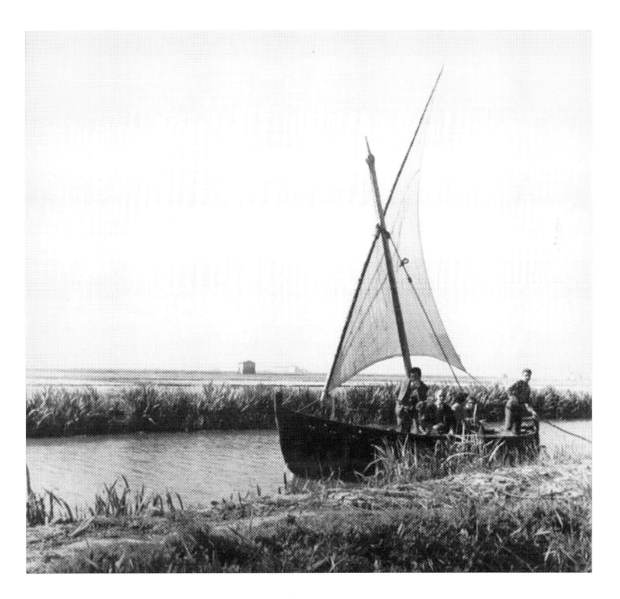

...along with transportation..

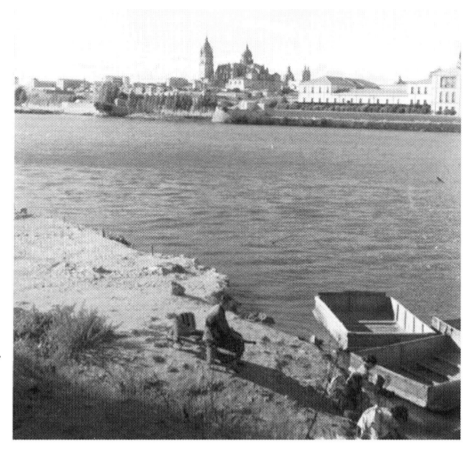

...and water...

for other needs.

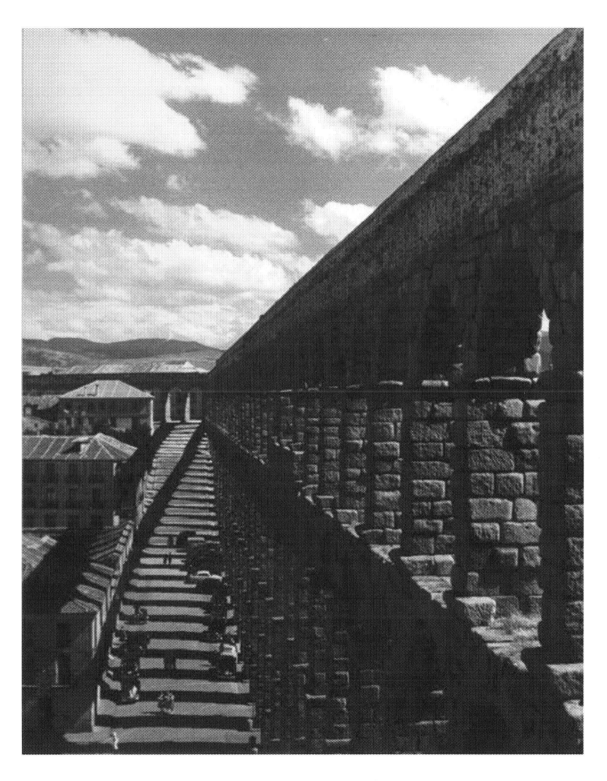

The Spanish still use old Roman aqueducts,

as in Segovia...

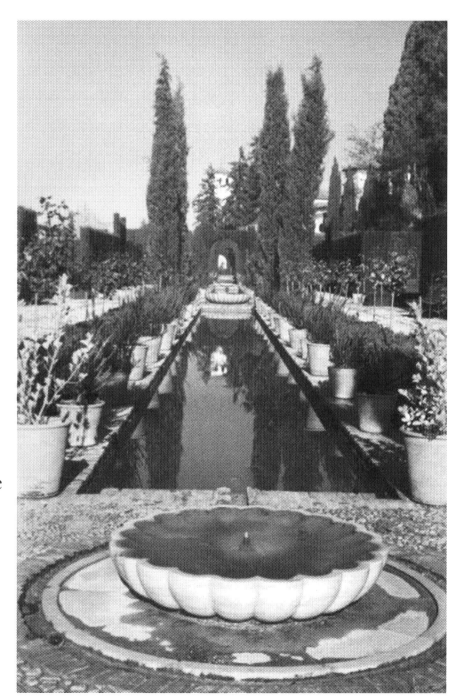

...and continue to preserve the Arab gardens and fountains

at the Alhambra in Grananda...

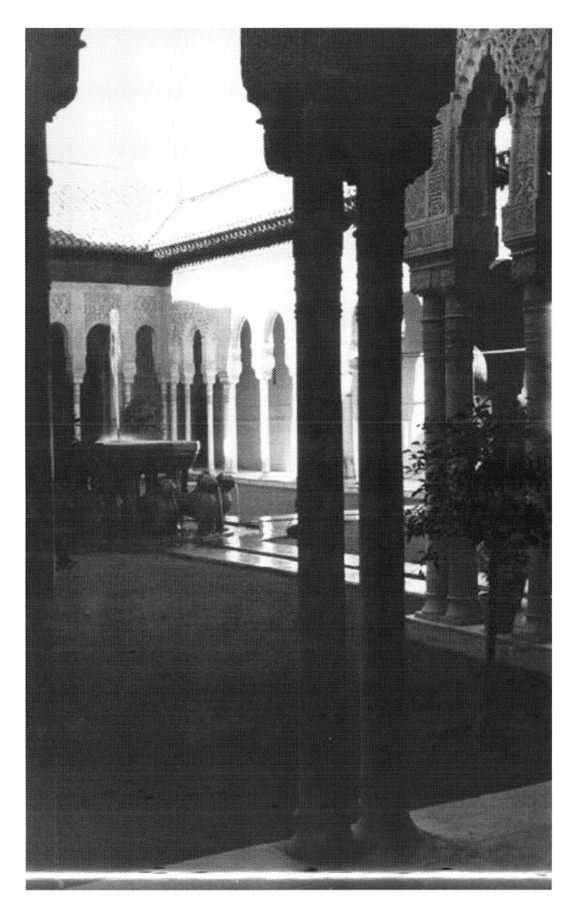

...in addition to more recent beauty spots.

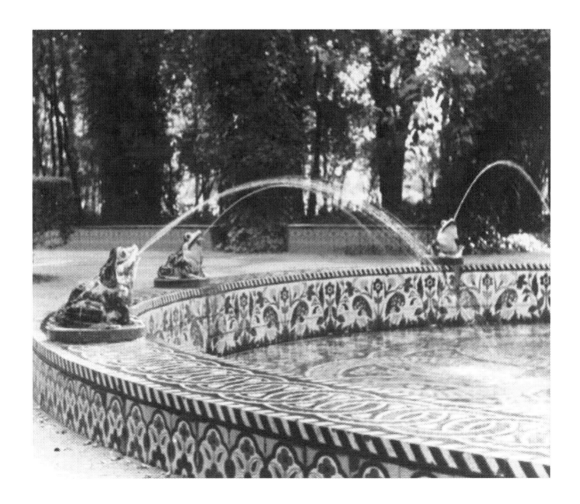

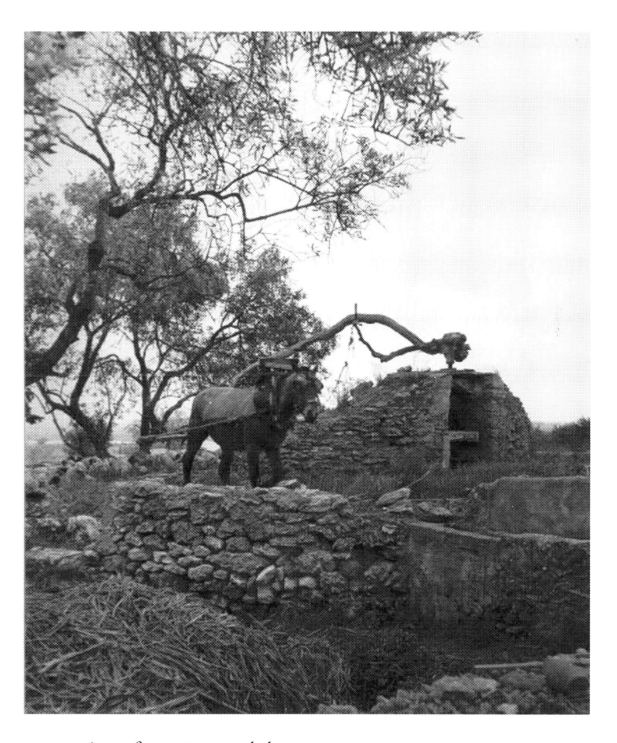

Away from rivers and the sea, water is
obtained laboriously from deep wells.

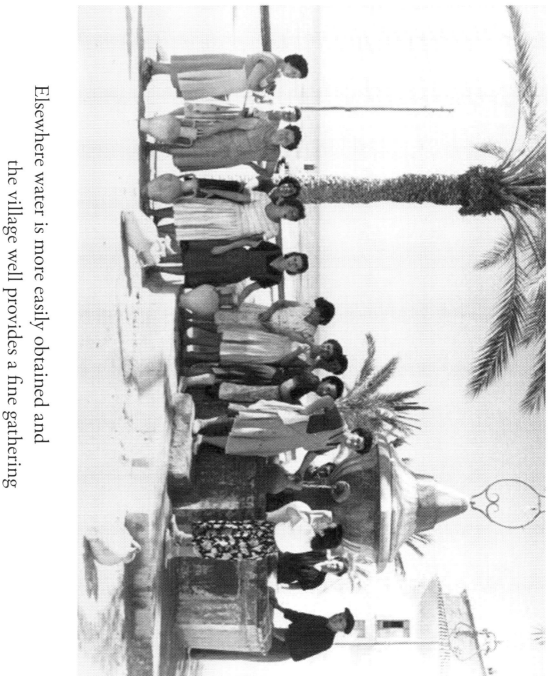

Elsewhere water is more easily obtained and the village well provides a fine gathering place for exchanging the day's gossip.

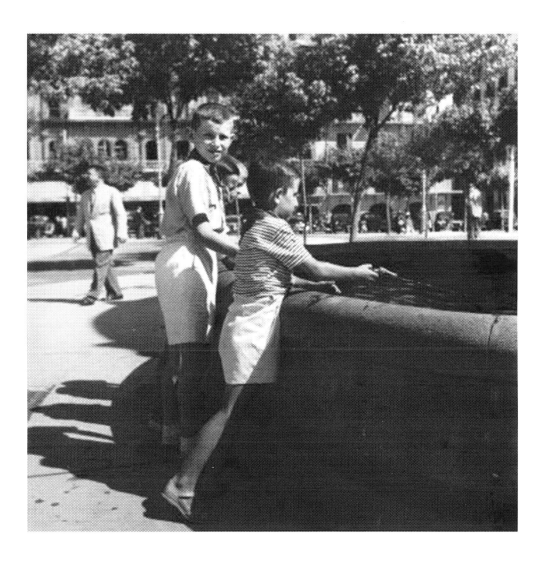

No matter where one travels in Spain, water
is notable for either its presence...

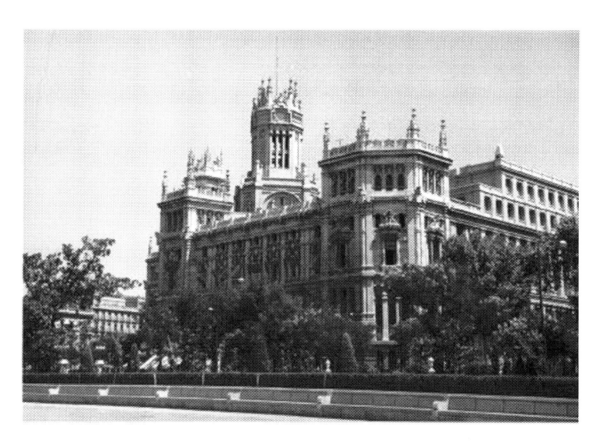

Life in Spanish cities moves as in all cities...

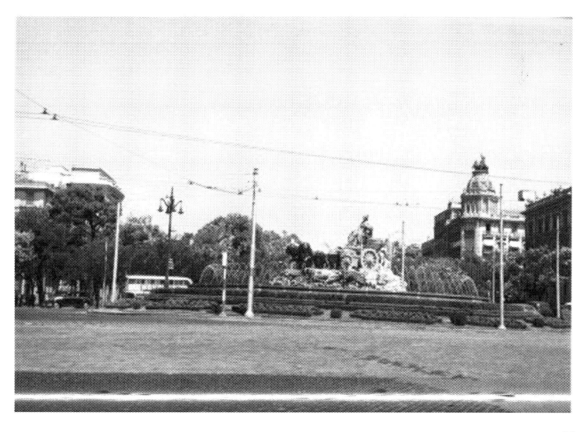

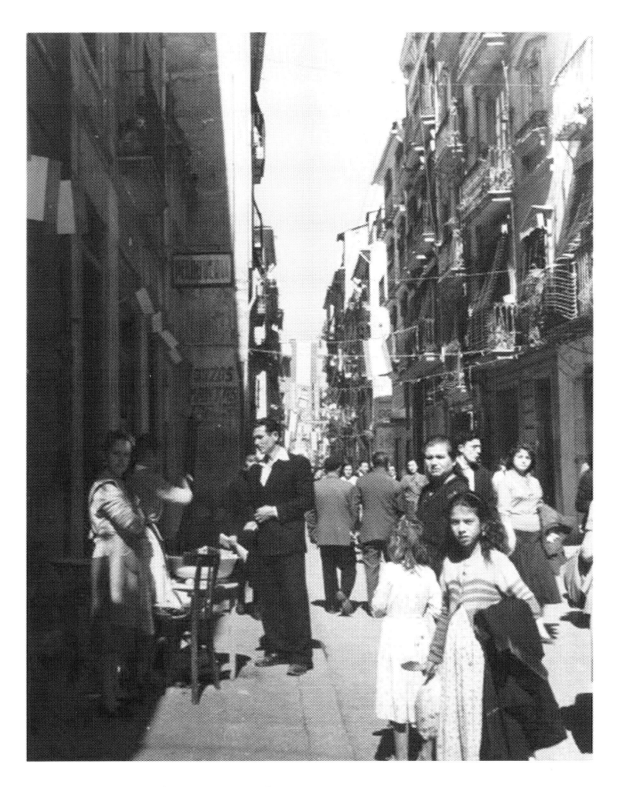

...**but** with a character peculiar to Spain...

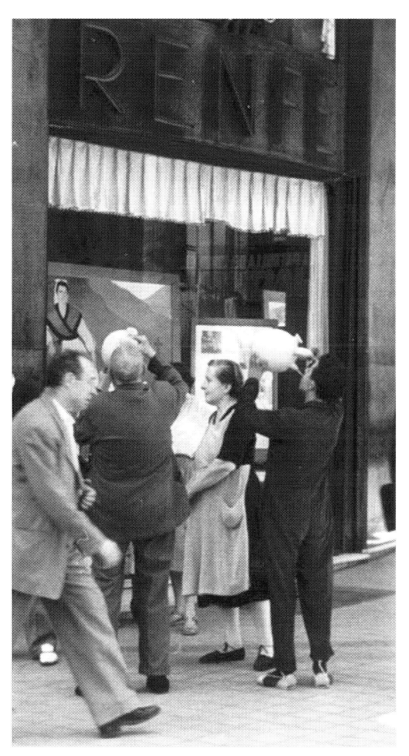

...with drinking water
sold on the streets...

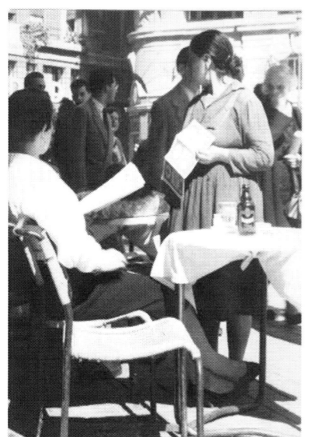

...sidewalk cafes with the inevitable
lottery ticket peddlers...

...shoeshine boys...

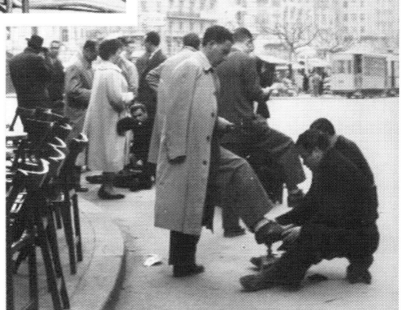

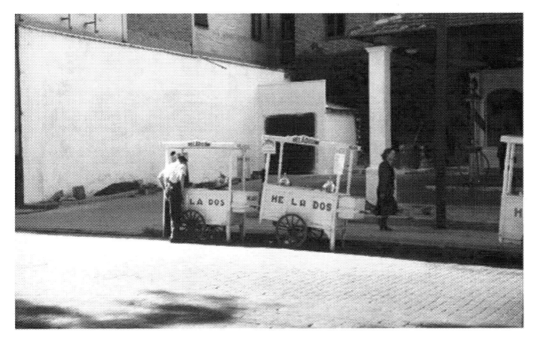

...ice cream...

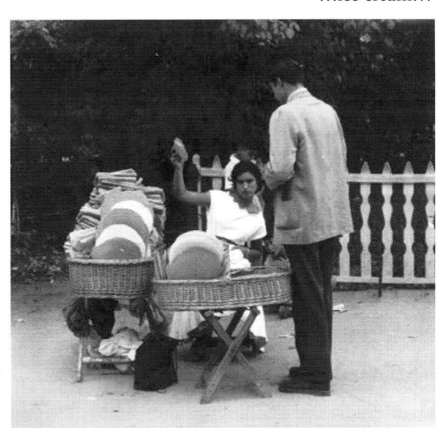

...and wafers...

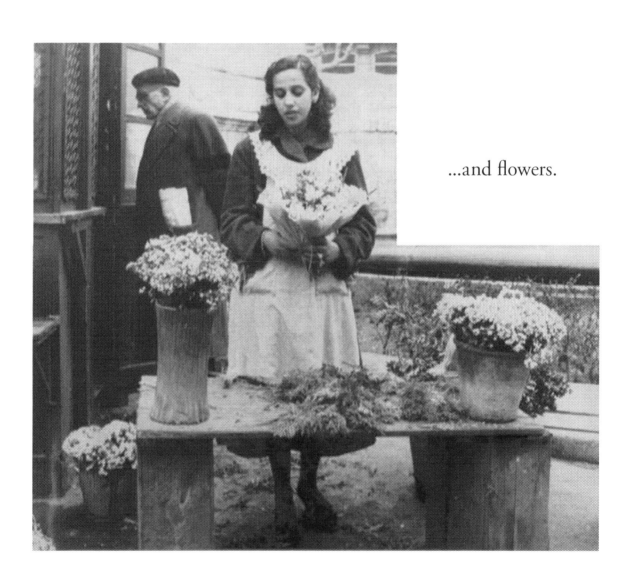

...and flowers.

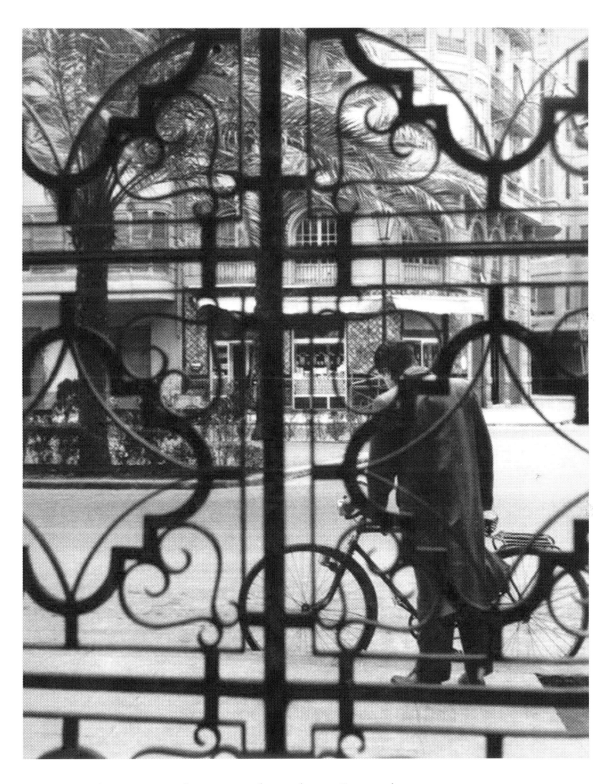

Apartment living is the role in Spanish cities…

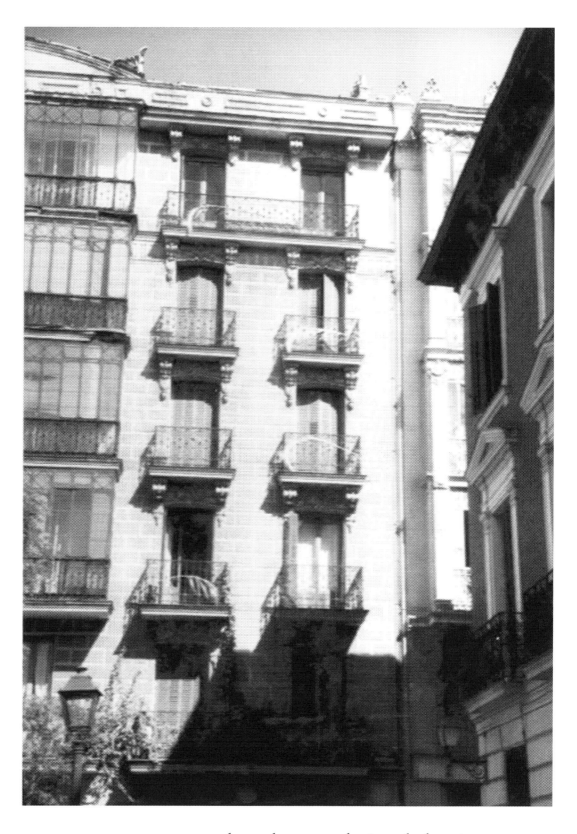

...where the wrought iron balconies...

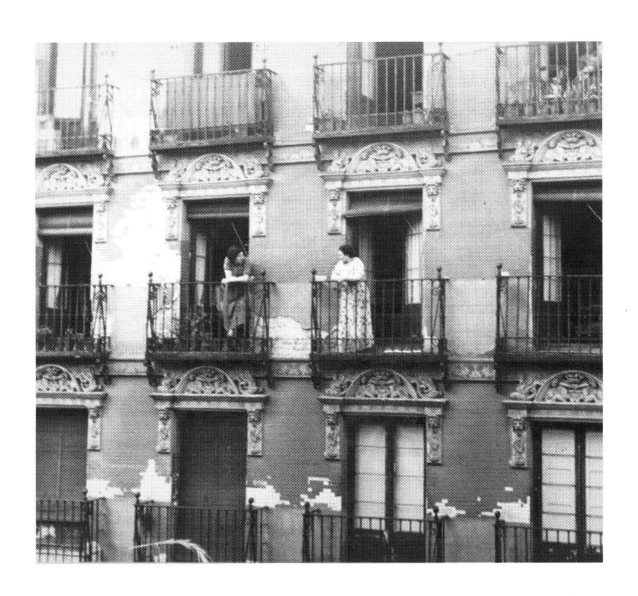

...offer easy opportunity for gossip...

...which may be carried on

in sidewalk cafes...

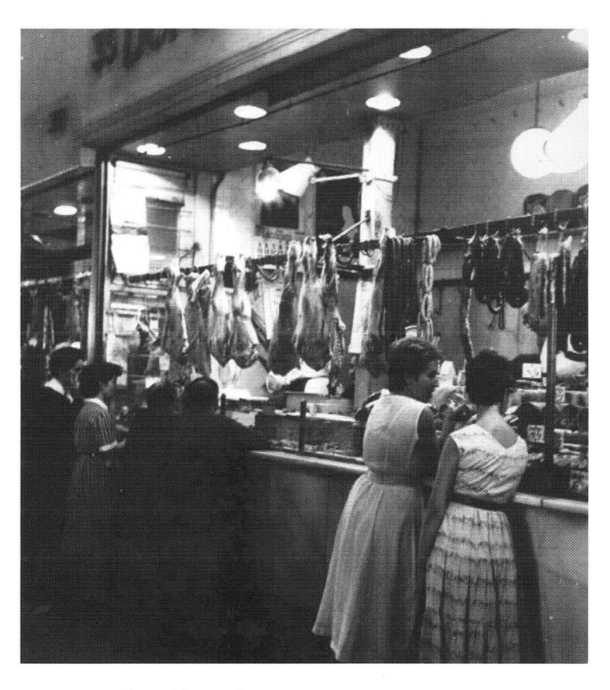

...or at the public market.

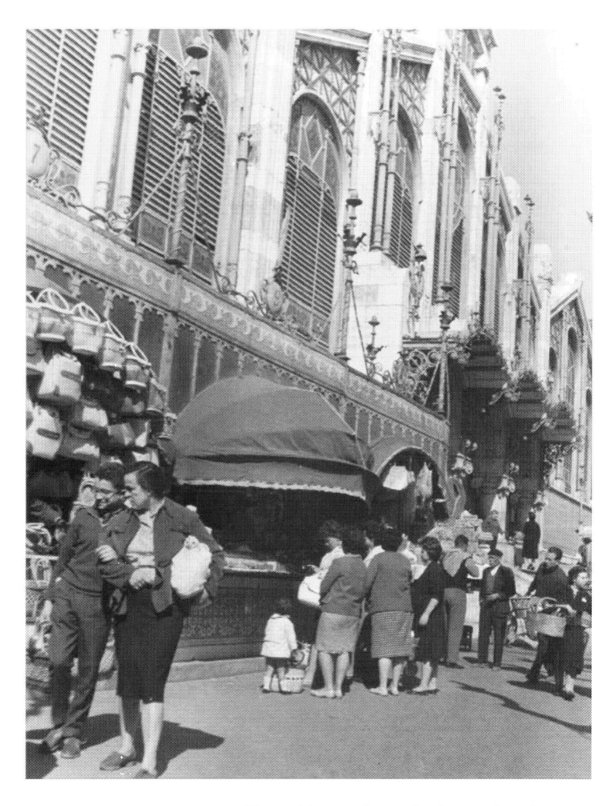

The public market, whether enclosed...

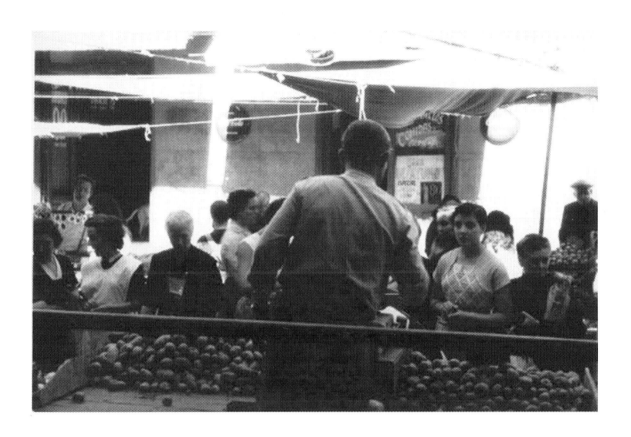

...or in the street...

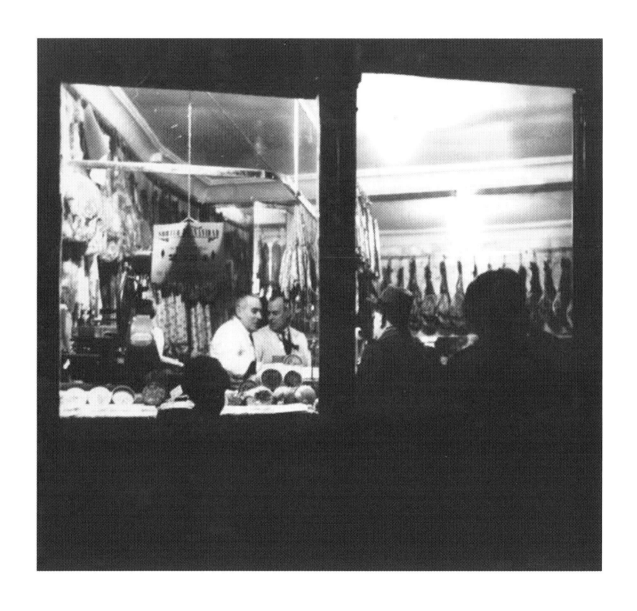

...is an important part of life in Spain

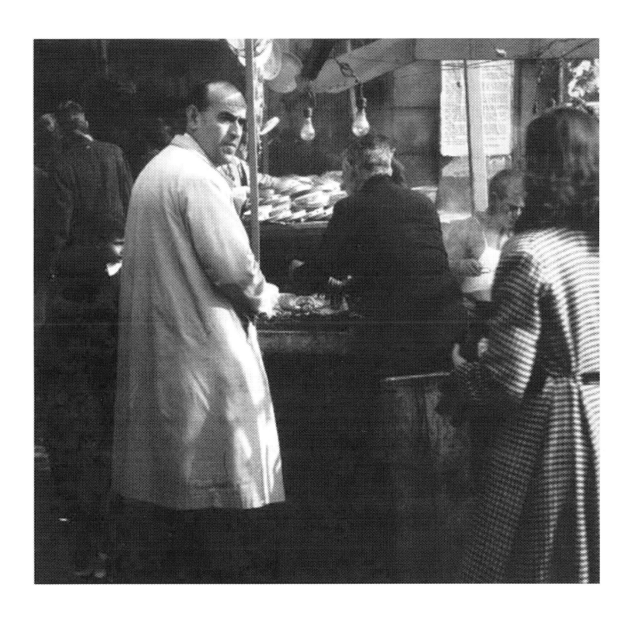

Not only food, **but...**

...utensils, baskets...

40

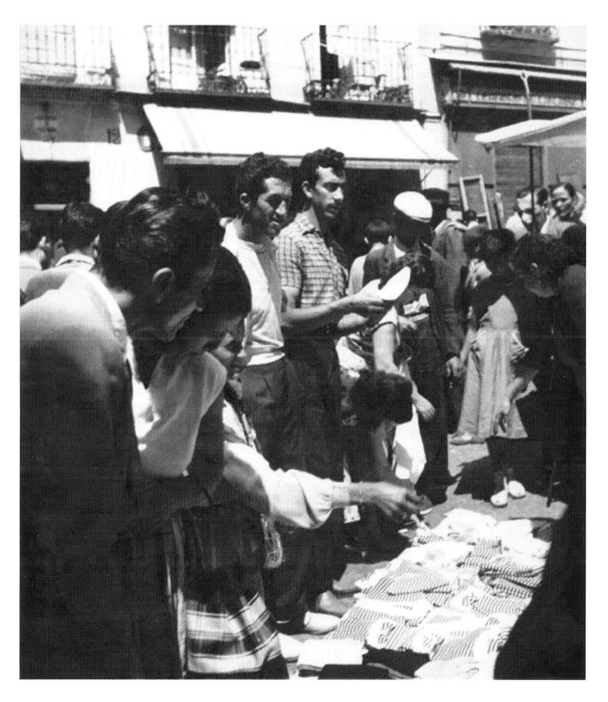

…clothes…

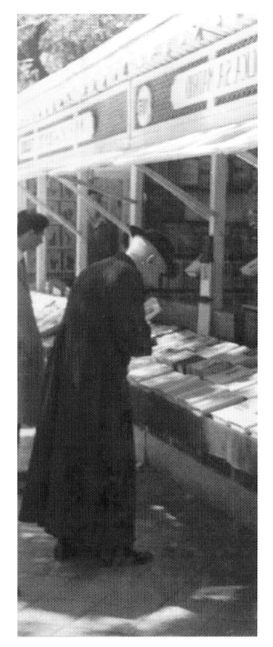

…books…

…birds…

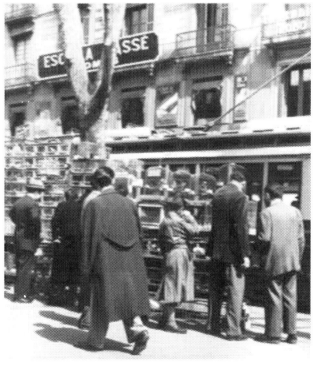

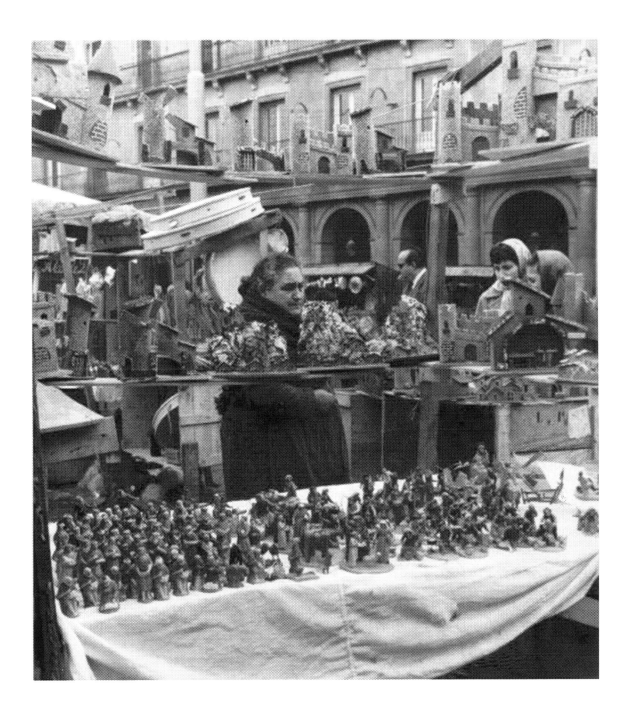

…and toys…

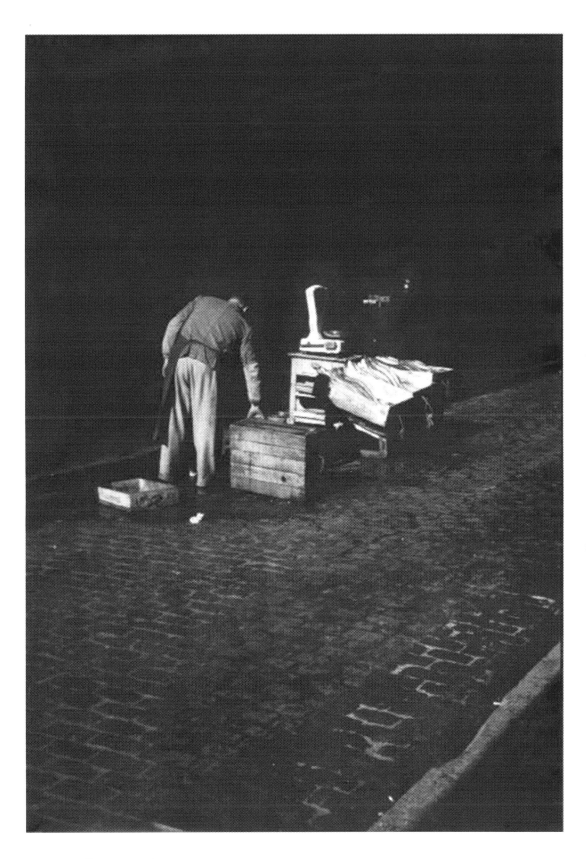

...from early morning...

...to late at night.

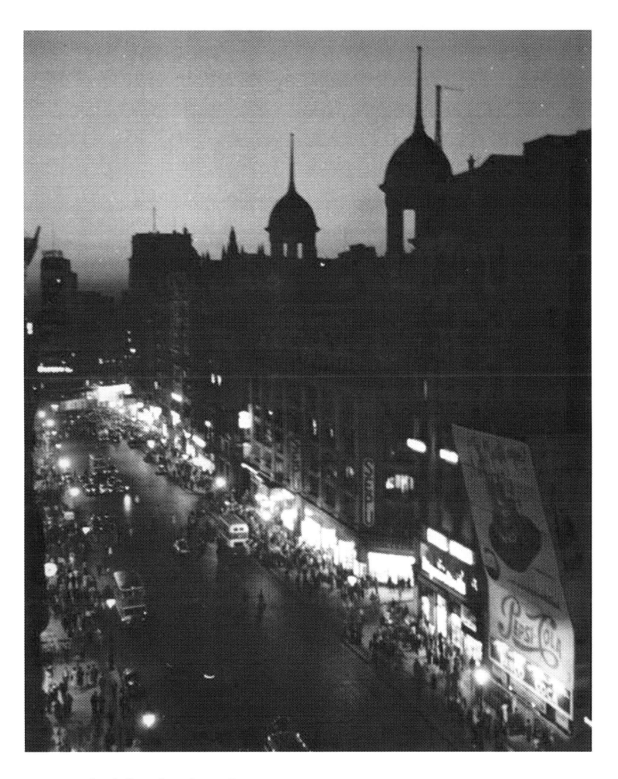

Night life is brisk in Spain...

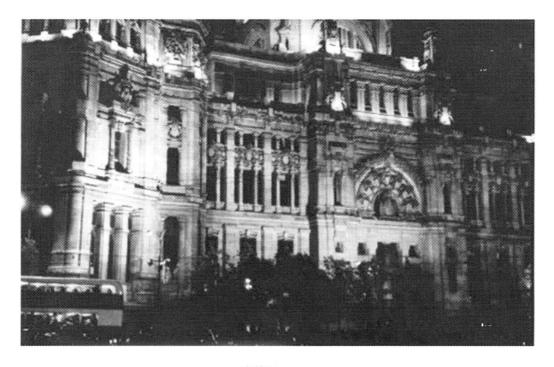

...and lighting of the city buildings,

fountains...

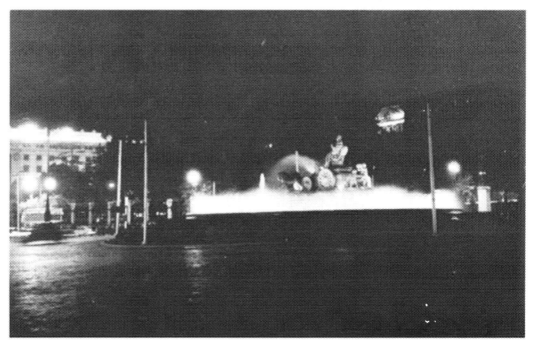

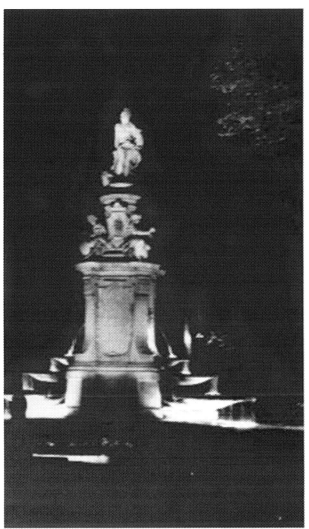

...monuments...

...and churches...

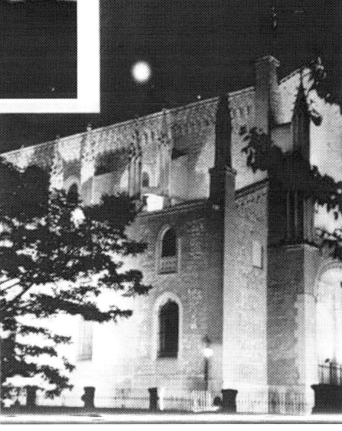

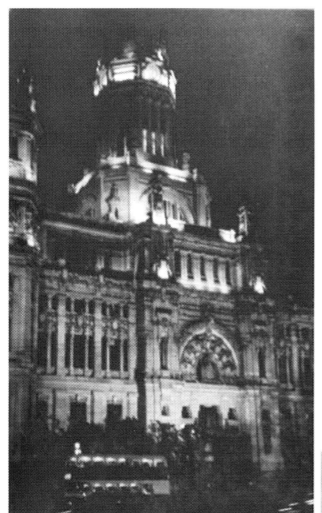

...and to the festive atmosphere.

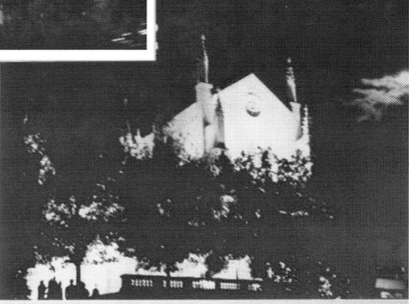

There are nightclubs,

either traditional

or avant-garde...

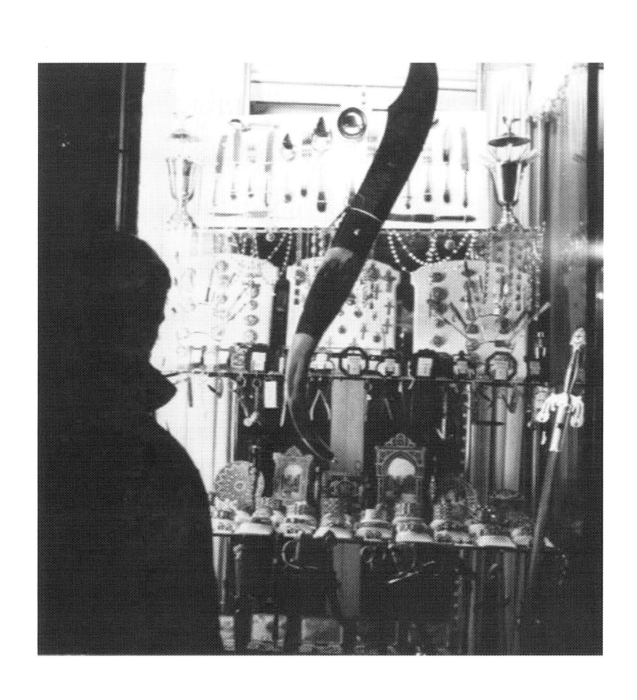

...but most people prefer window shopping...

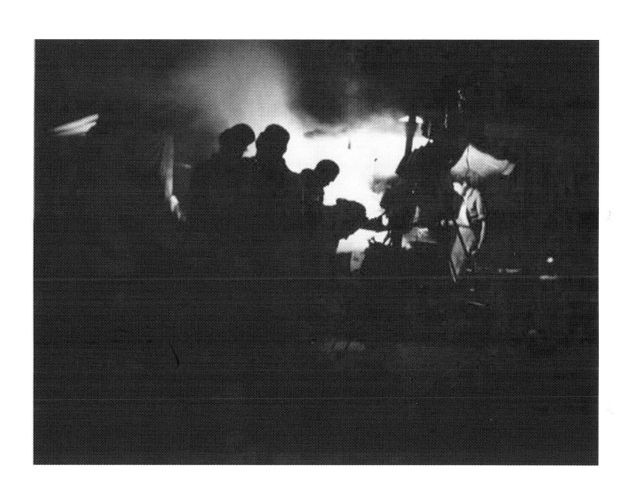

...or the simpler pleasures of
eating at sidewalk stands or...

...mingling with other people until late...

...for there is always time next day for a siesta.

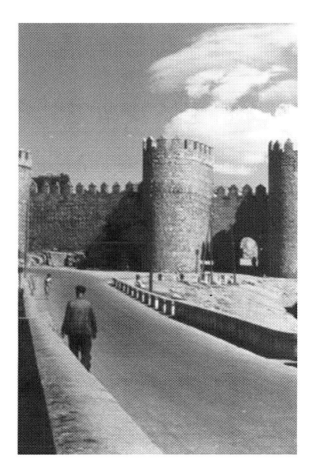

The past is

 ever present...

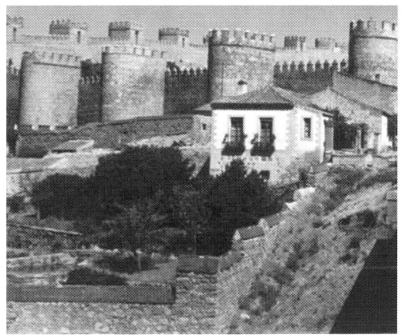

 ...in Spain...

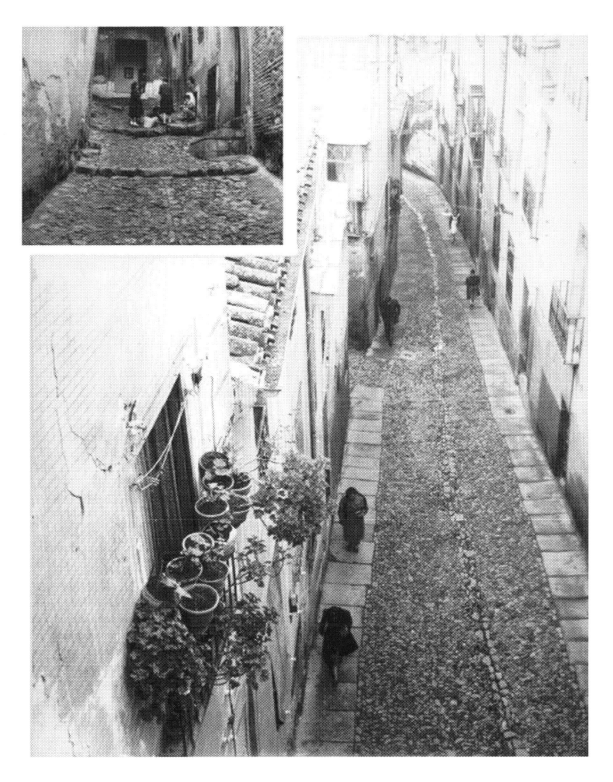

…not only in the narrow cobbled streets with central drainage

but in….

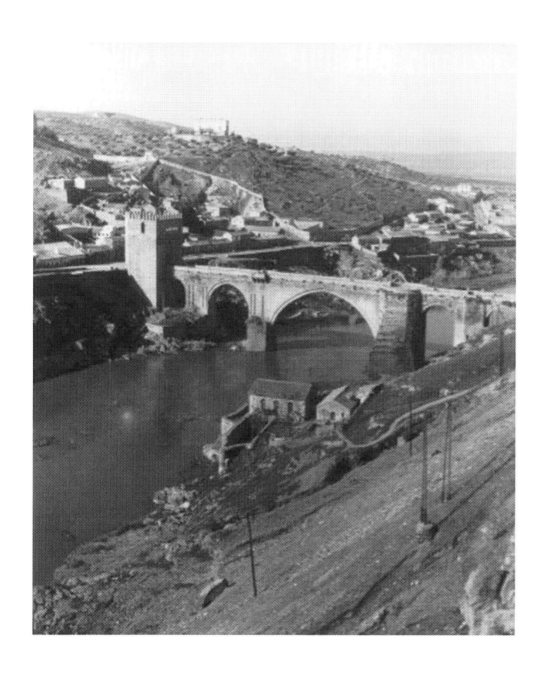

...bridges built by the Romans and still...

...in use

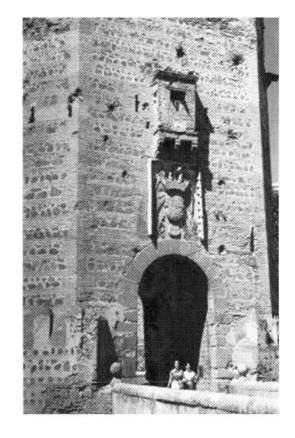

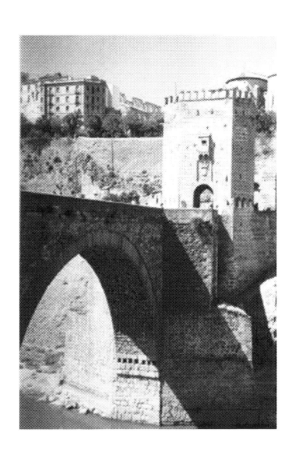

...today.

Later Arab influences...

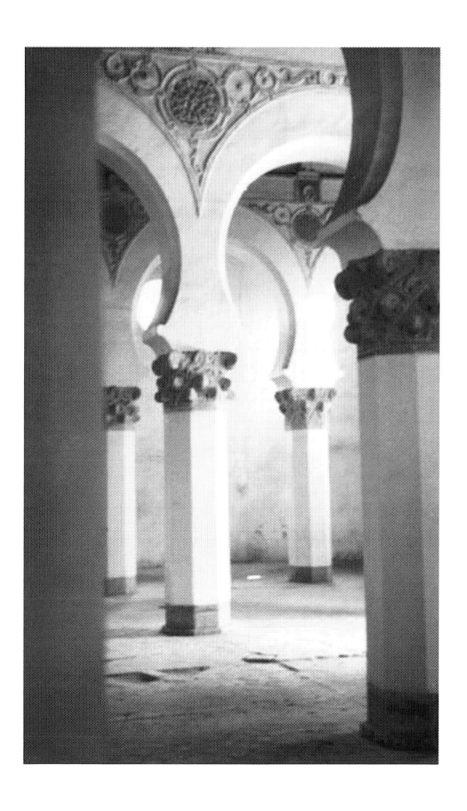

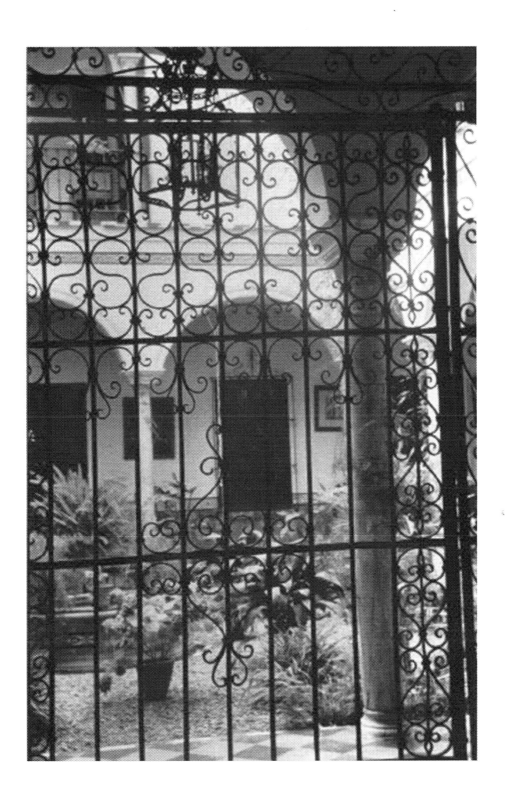

...are found in the wrought iron gates...

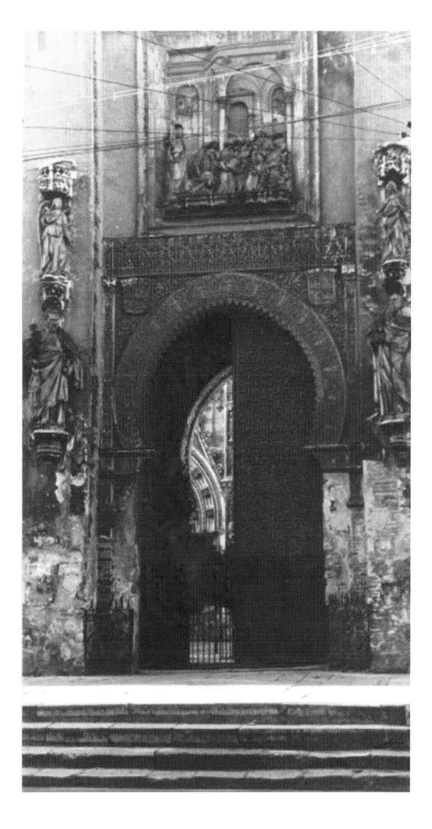

...cathedral doors...

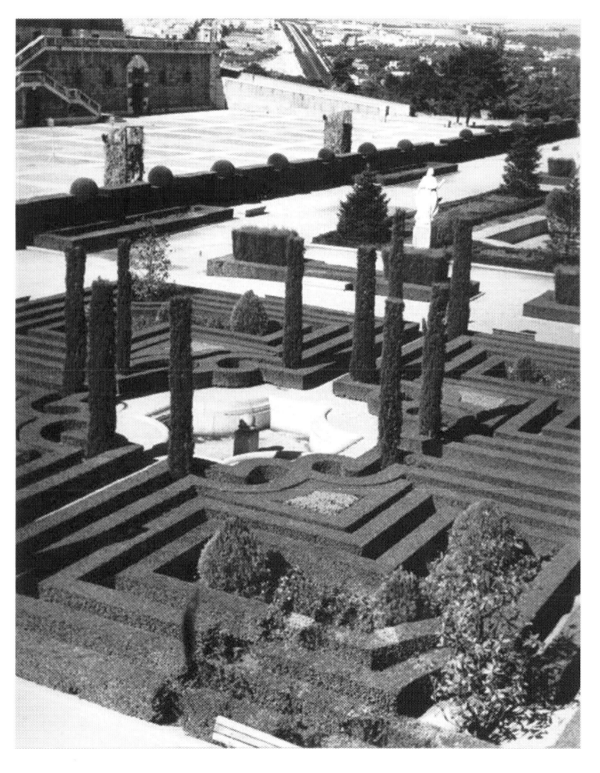

...gardens...

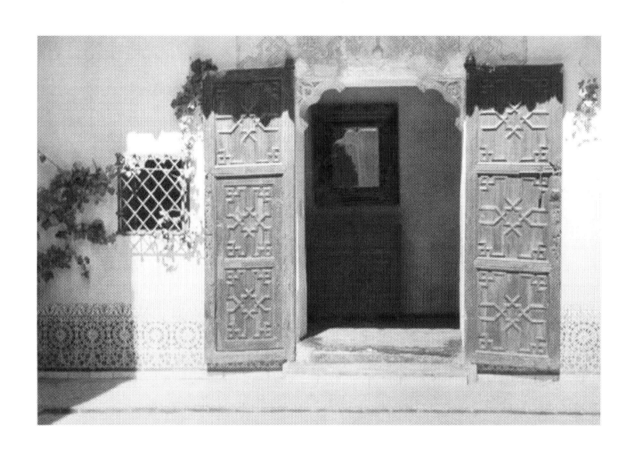

...decorations...

...and mixed with Roman as in this arch.

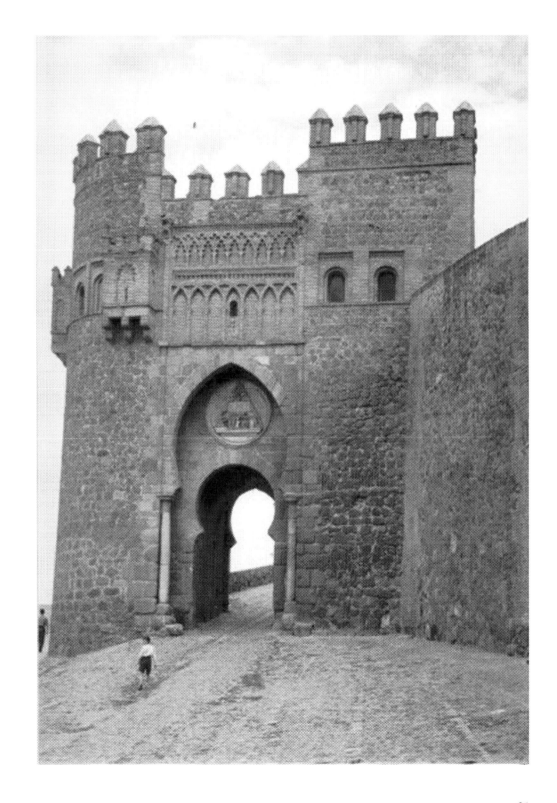

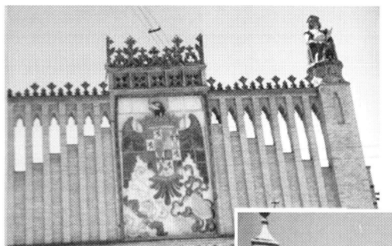

This fusion of

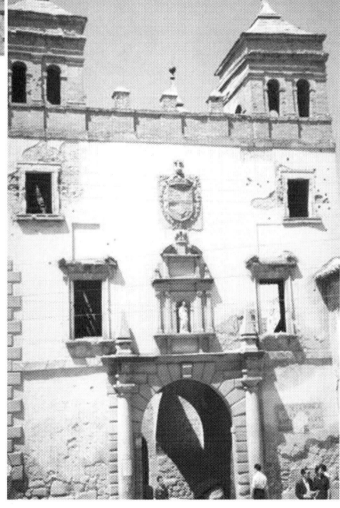

...Roman, Arabic and later royalties is evident everywhere in facades...

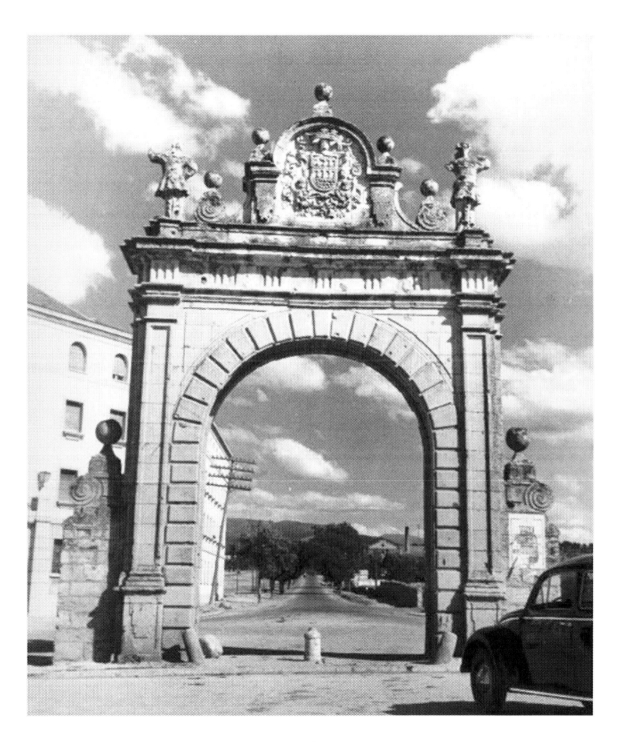

…arches…

...monuments...

...columns

...and even plaques on the road
signs to remove villages...

69

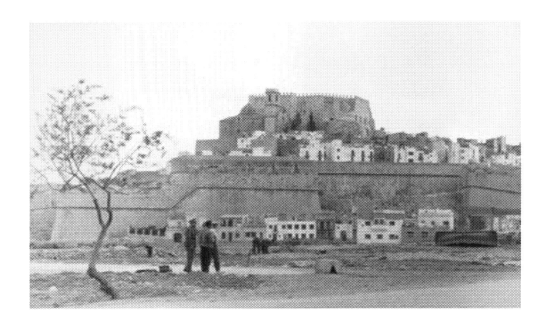

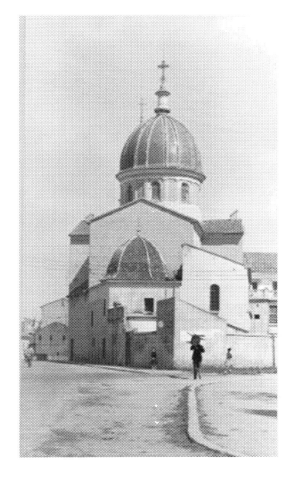

...where the past still lives
in the present.

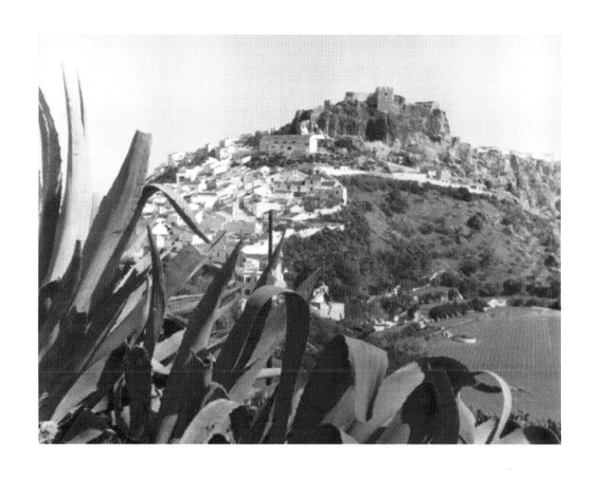

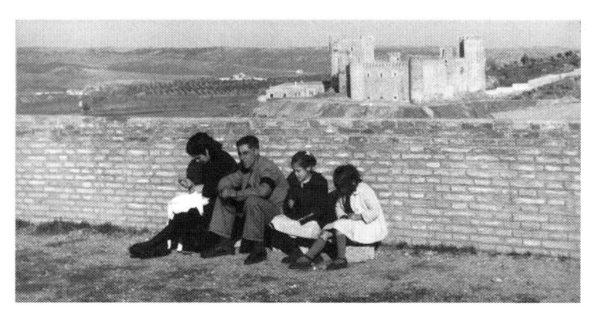

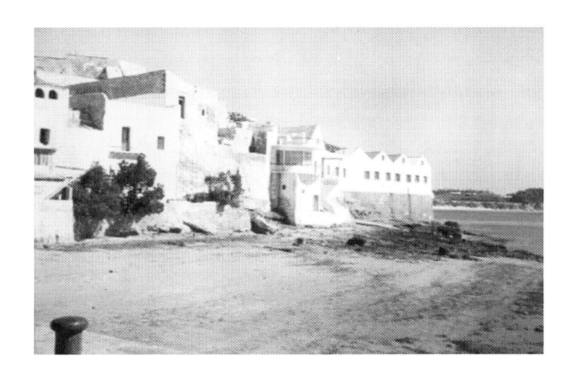

In these villages...

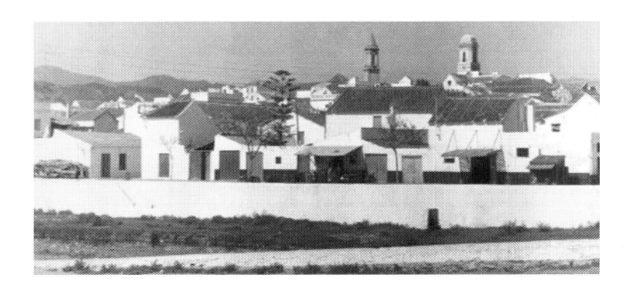

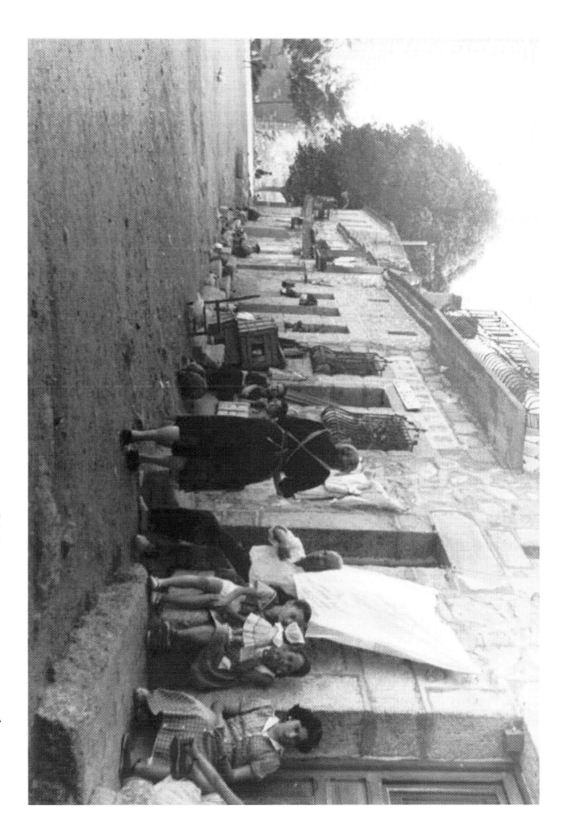

Living is more communal

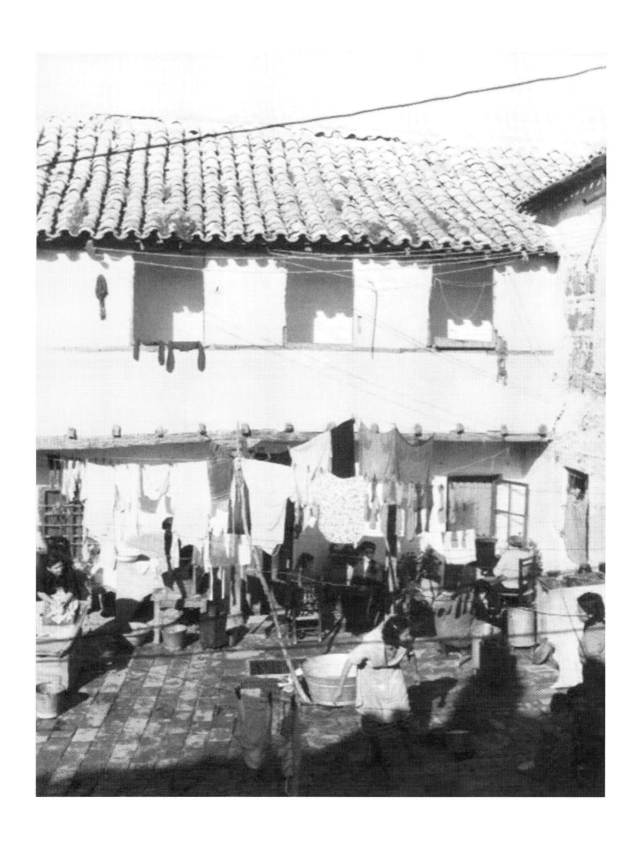

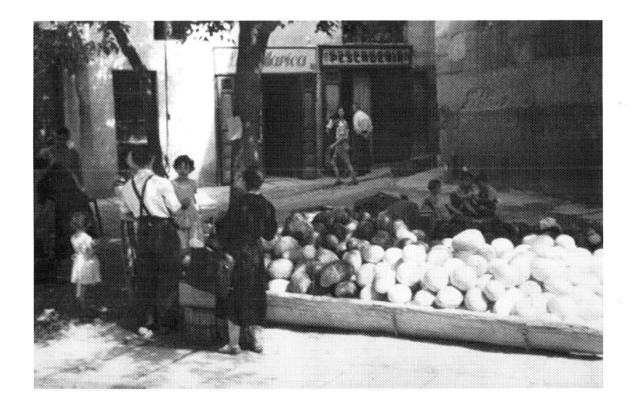

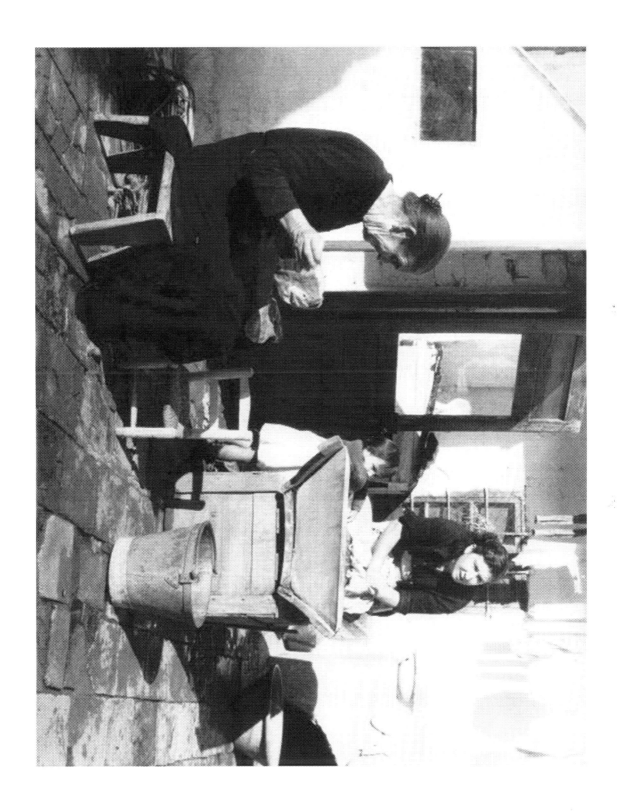

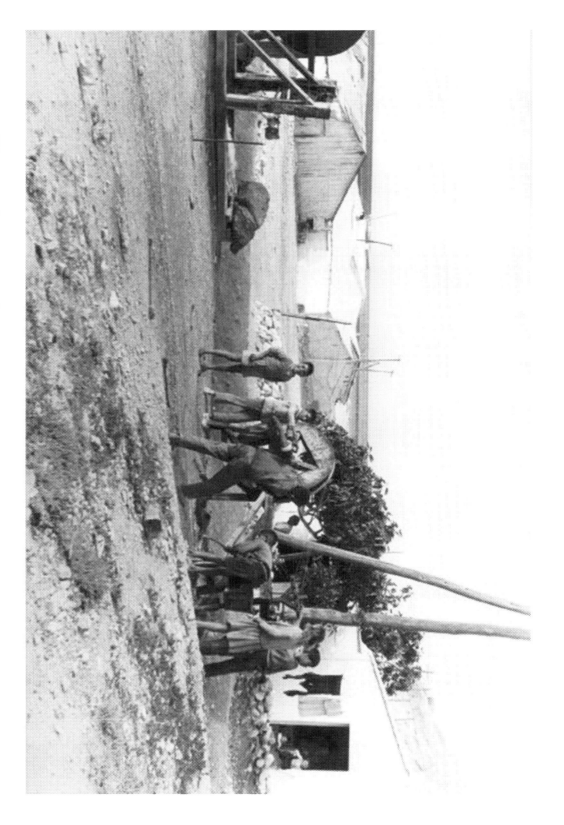

This maybe rope making

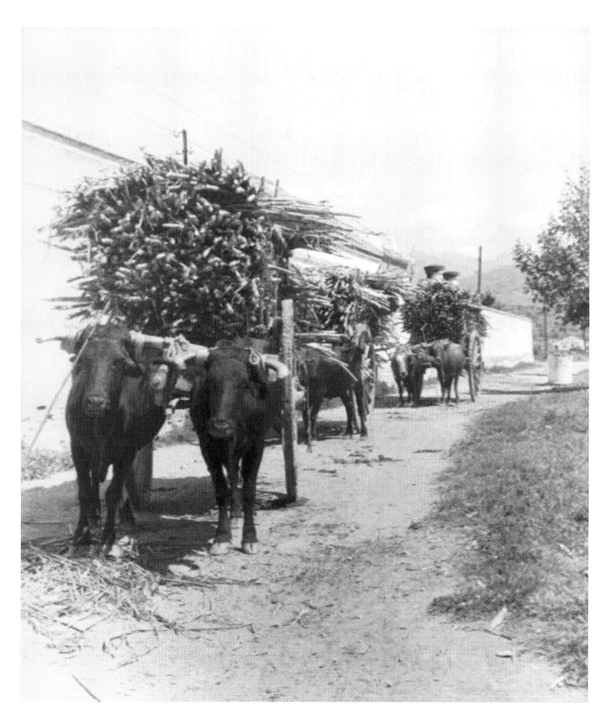

...hauling sugar cane...

which is often pile along the road.

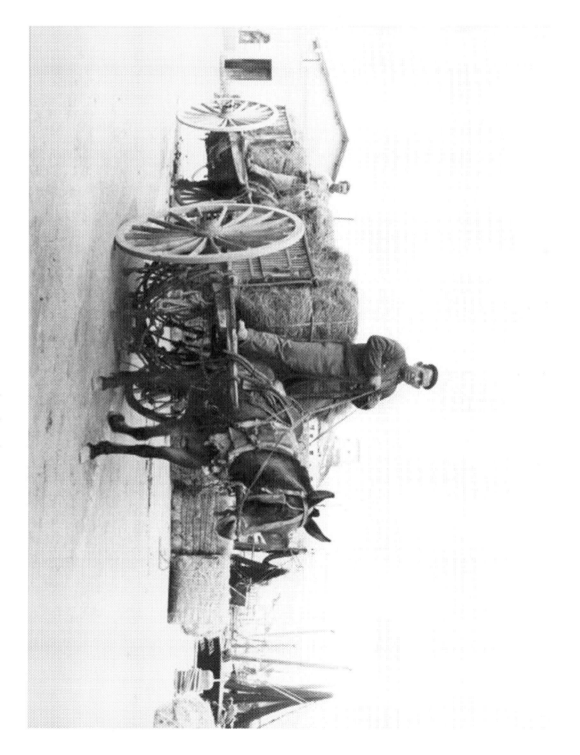

...carrying cargo to the harbor.

82

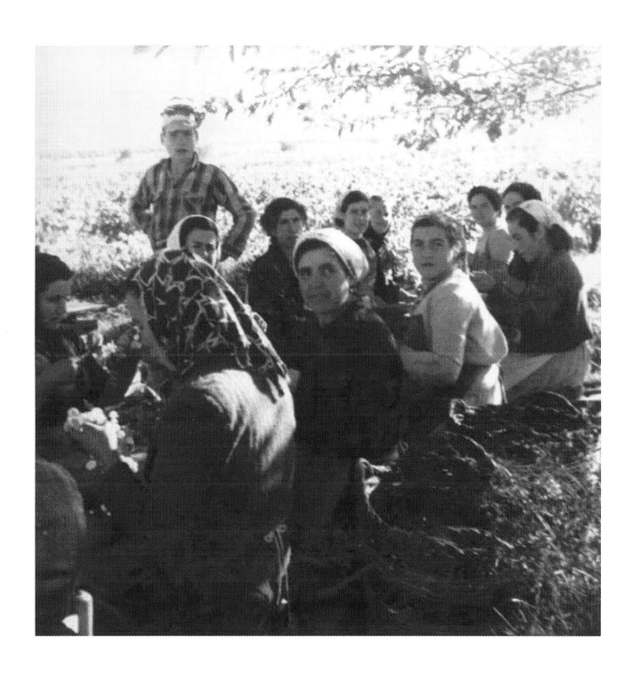

...picking grapes...

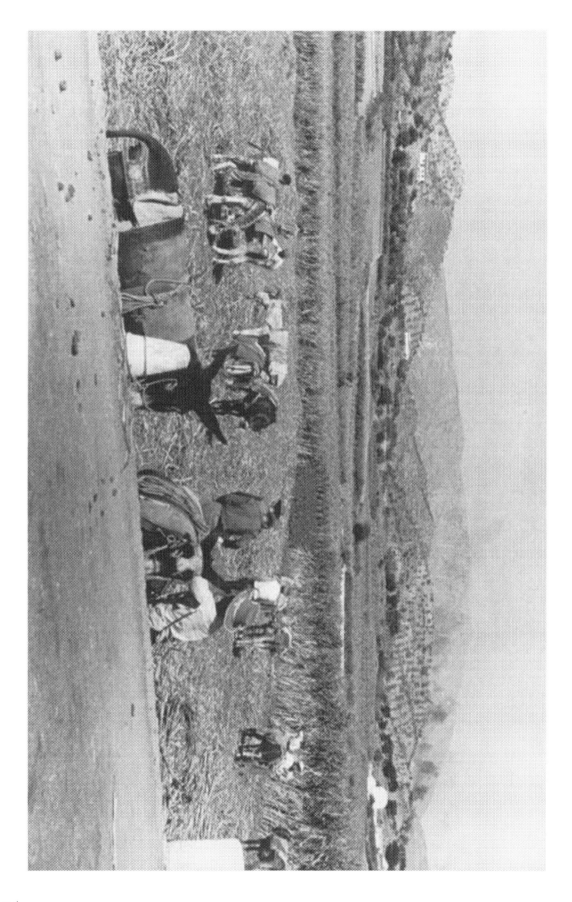

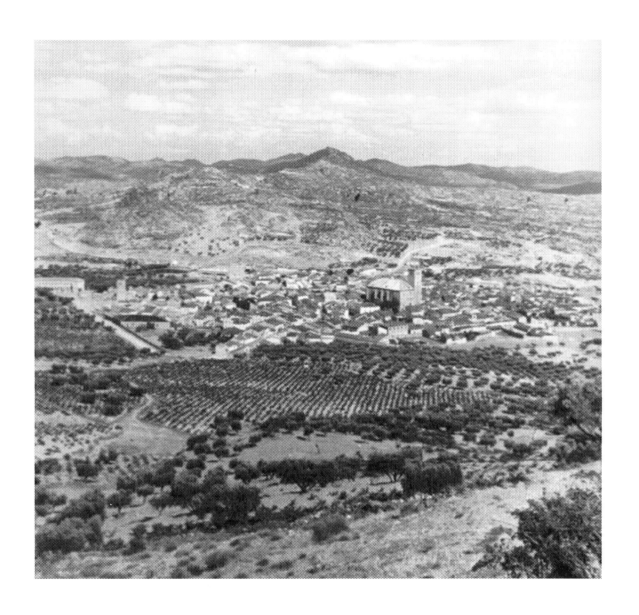

Orange groves and…

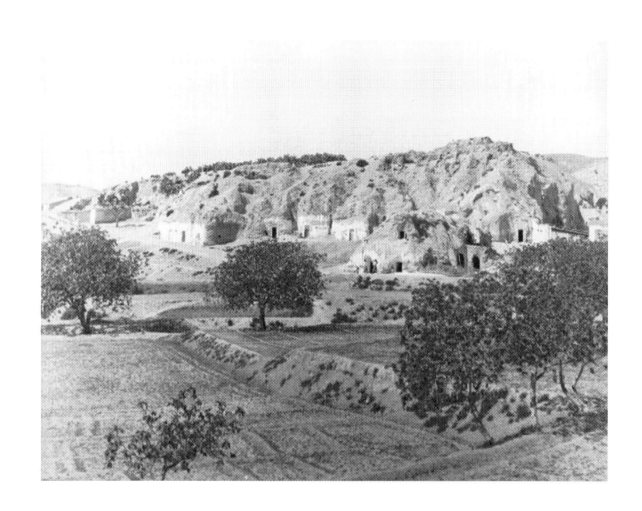

...olive trees are vital to Spain...

87

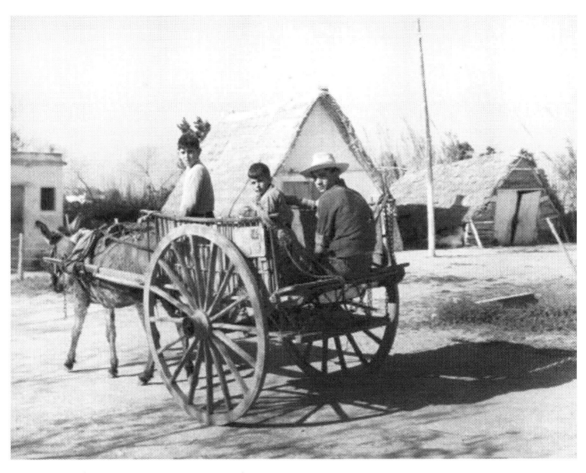

...still popular transportation.

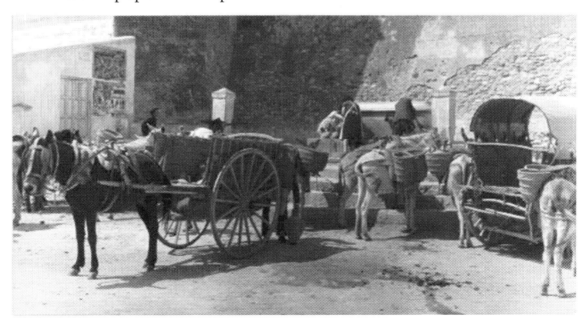

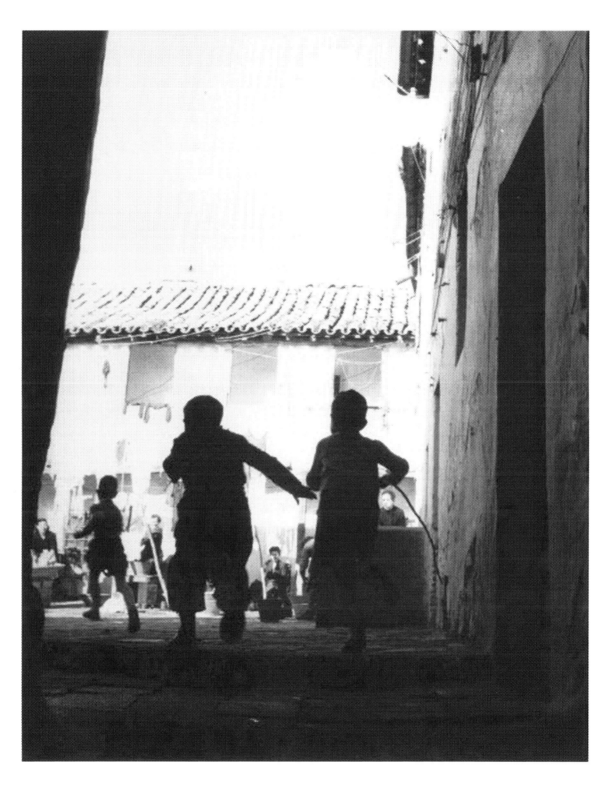

Village children run and play…

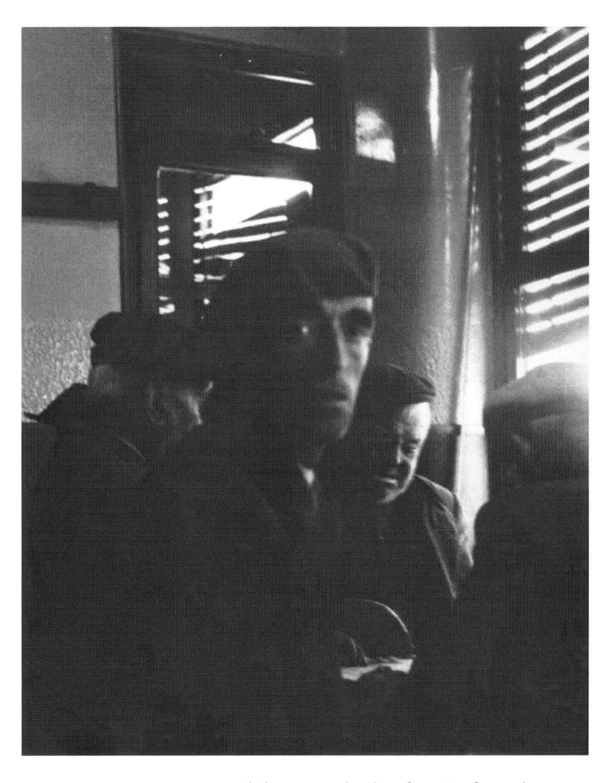

...while men seek a brief respite from the
sun with wine and dominoes...

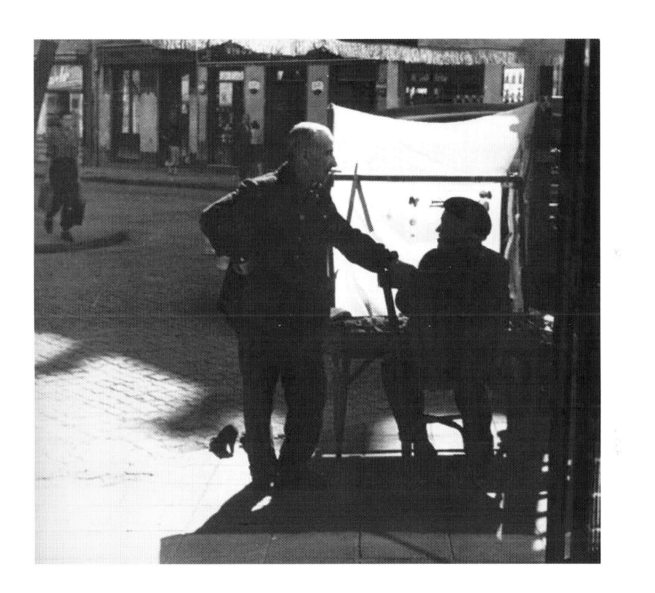

...chat for a few minutes in the shade with friends...

...or enjoy a bit

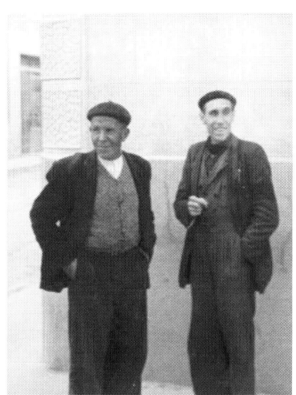

...of contemplation.

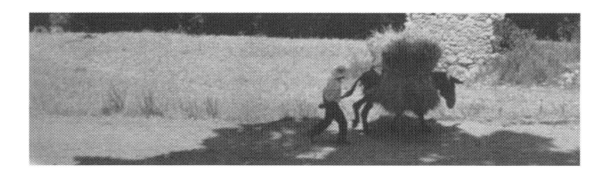

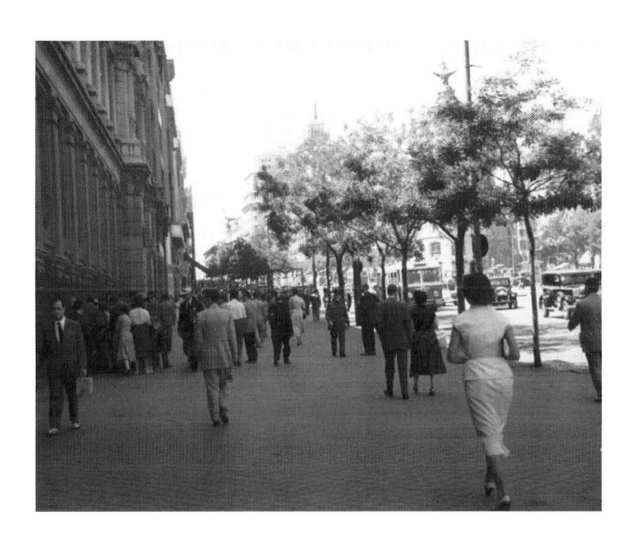

The rhythm of living is different in the cities...

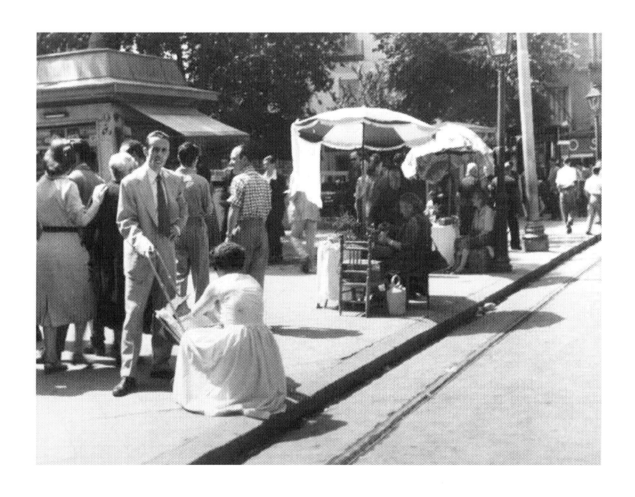

...with their sidewalk activity...

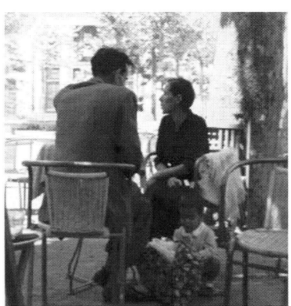

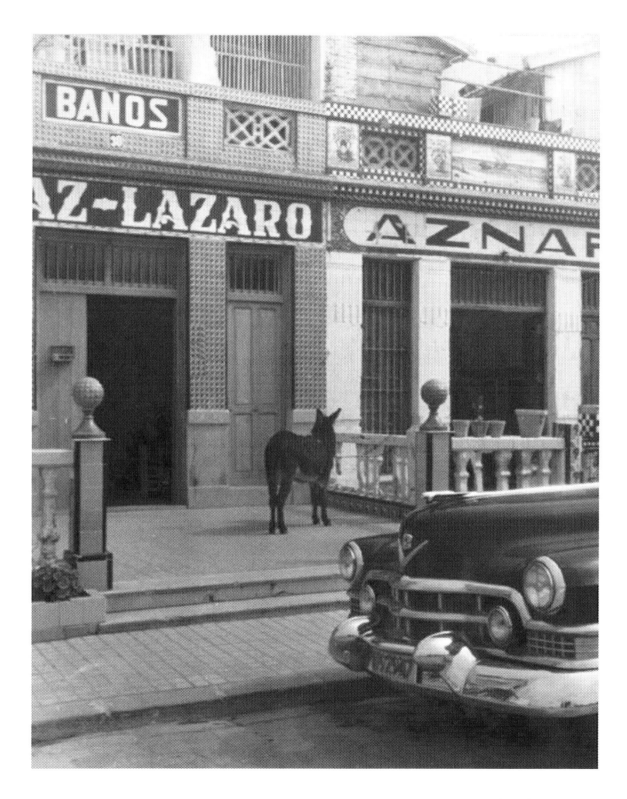

...contrasts..

…venders…

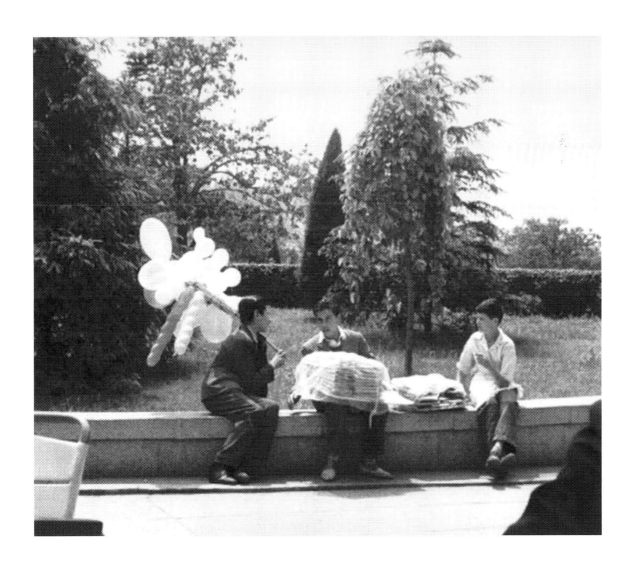

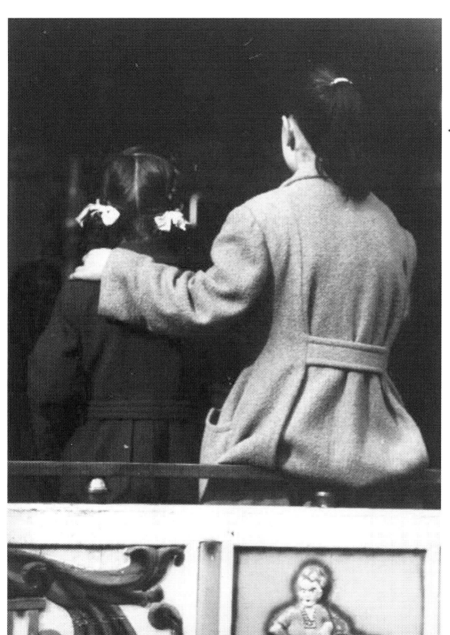

…and
street carnivals.

98

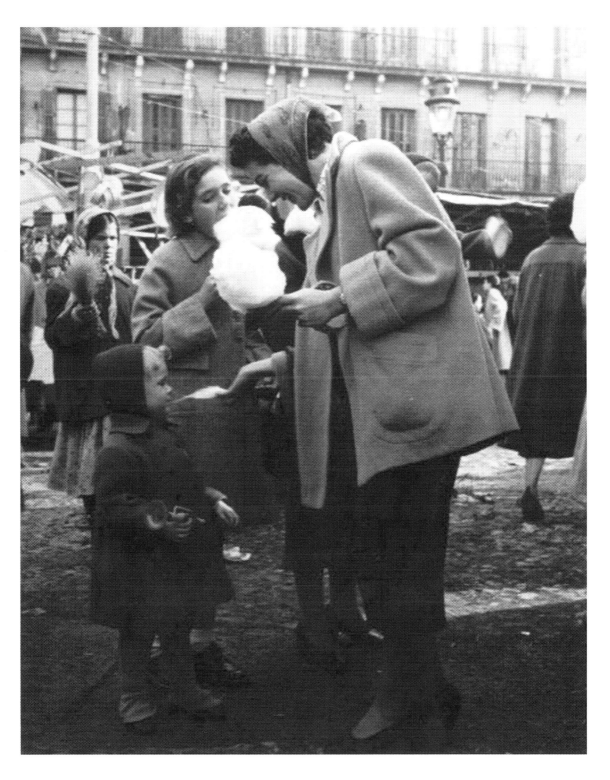

Spain's climate varies from cold in winter...

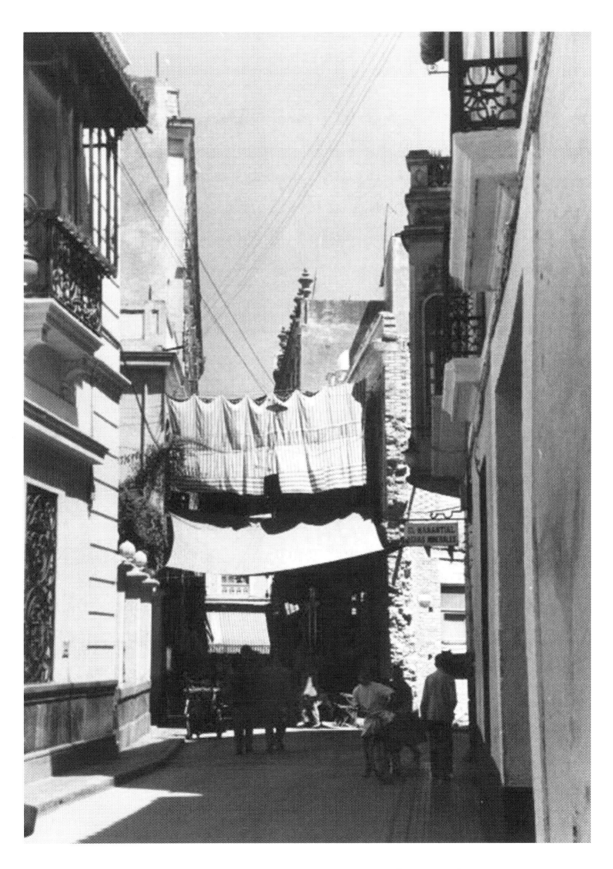

...to very hot in the summer.

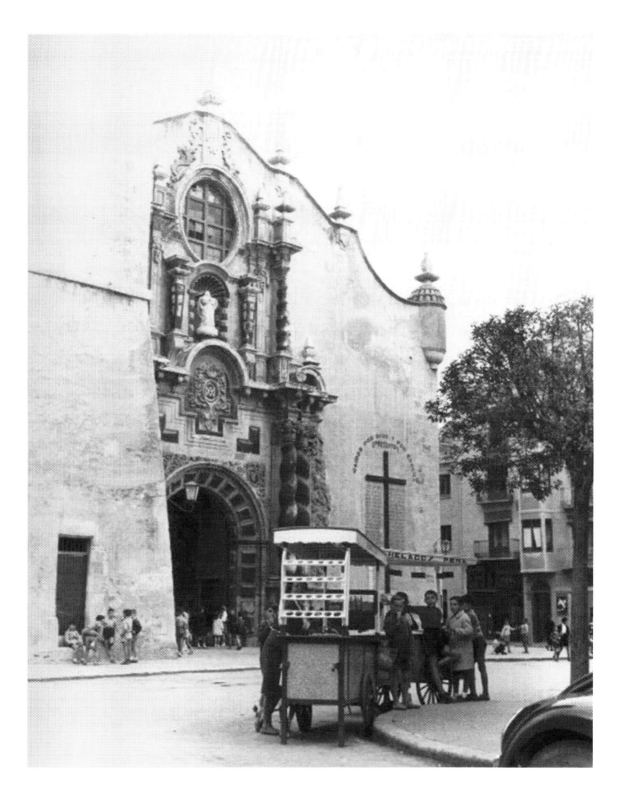

Every village has its church…

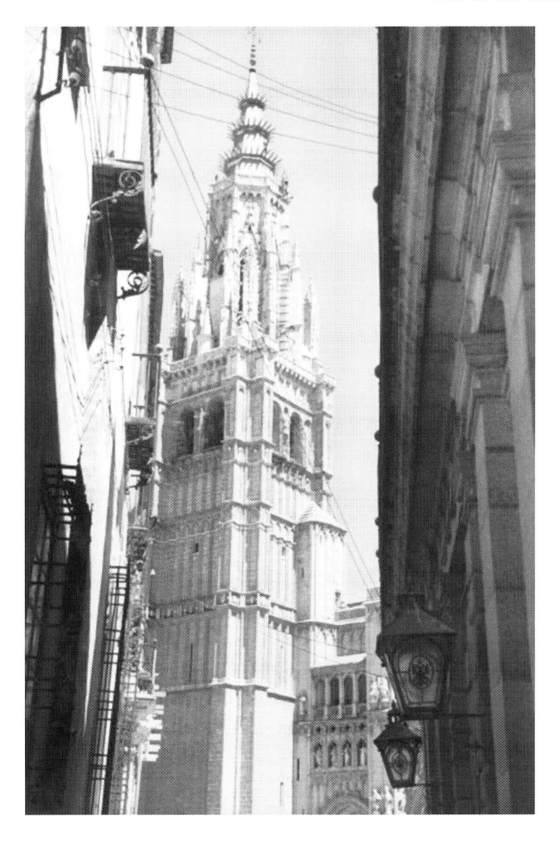

...with varied architecture...

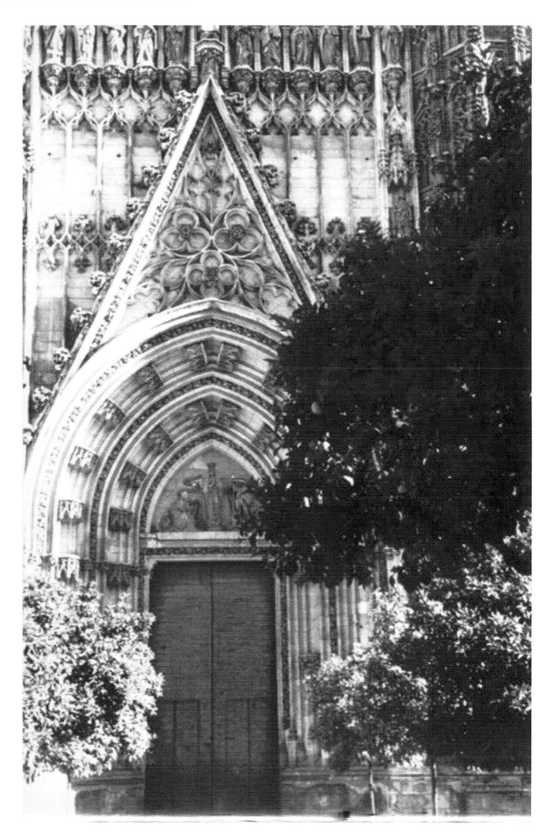

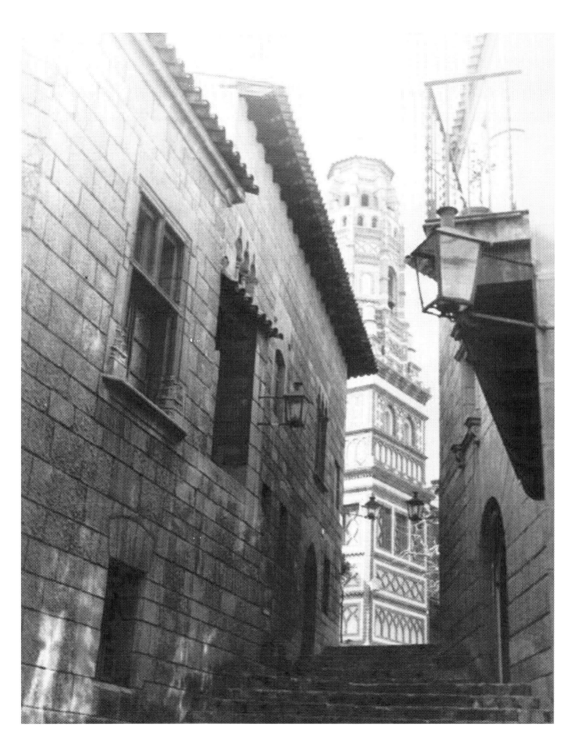

...following many...

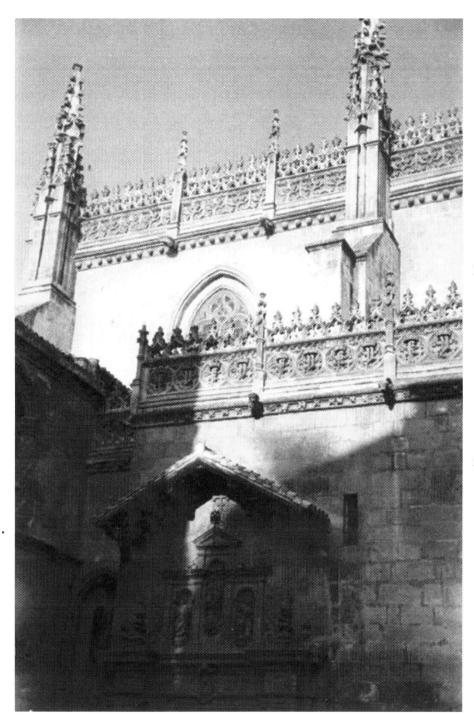

...styles and...

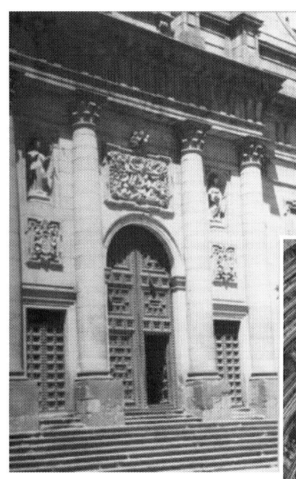

...decor.

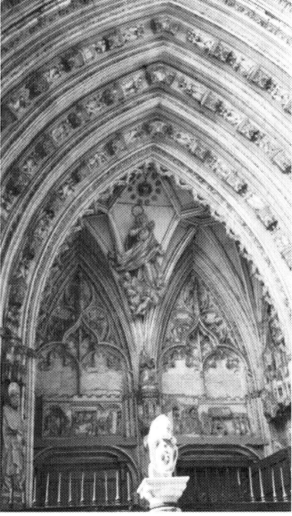

The
 people
 are
 very
 devout…

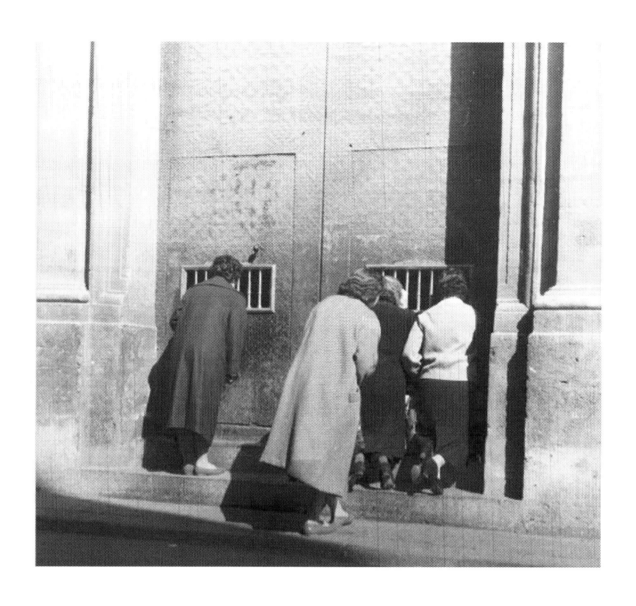

...often pausing during the day to pray outside the church door...

...and never forgetting that in Spain
prayer is part of every festival.

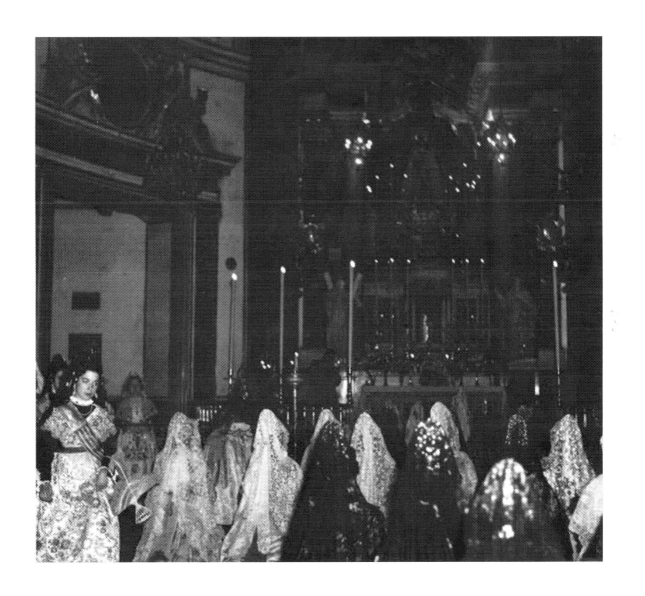

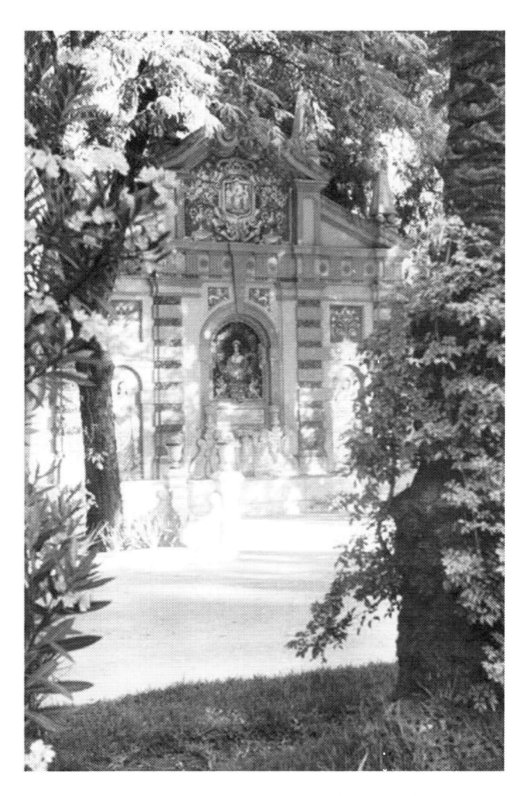

Religious grottos are found in most parks…

...and the monastery at Montserrat
 is a popular visiting place.

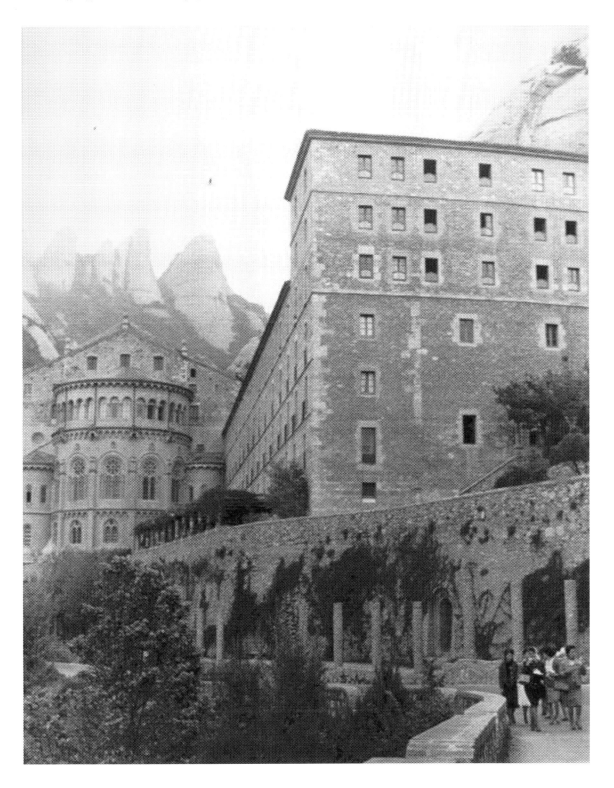

Many young men enter holy orders...

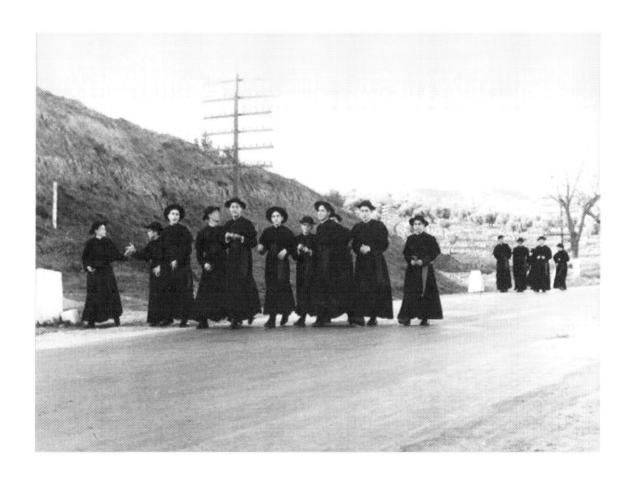

...as do the women...

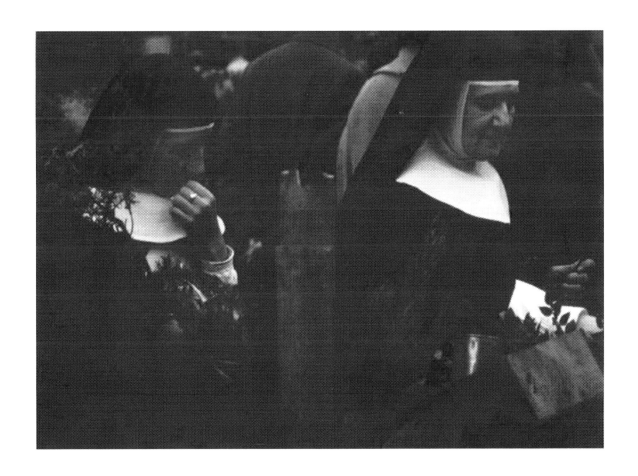

Each city and village celebrates a patron saint festival.

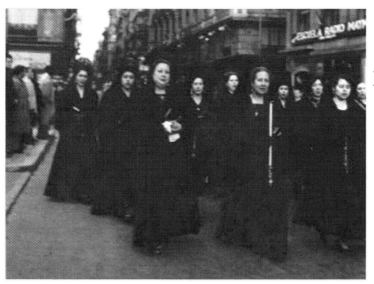

In Madrid the festival
is in honor of San Isidro...

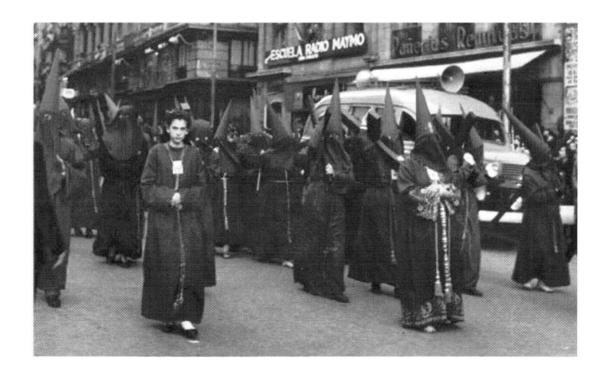

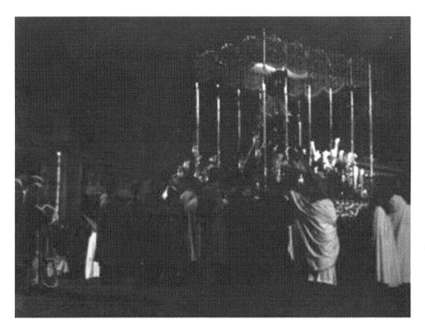

...characterized by

...day and night parades
of penitents...

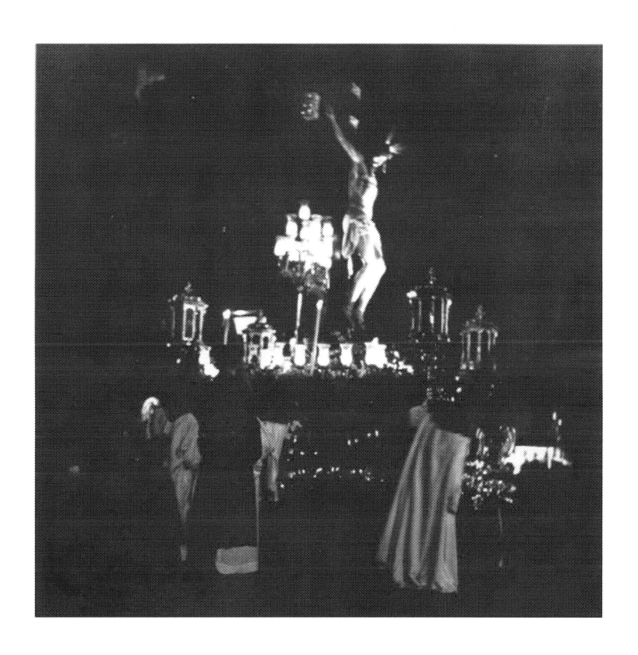

…carrying holy symbols and…

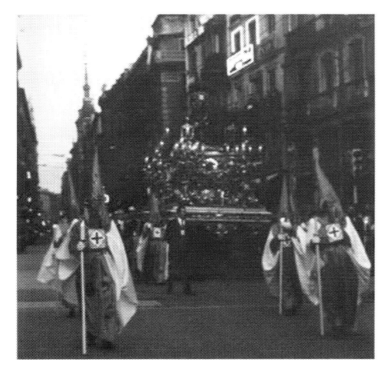

...wearing the traditional

...penitents' hoods.

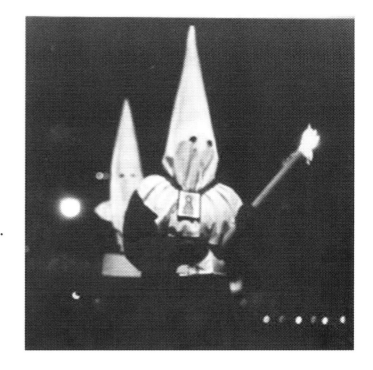

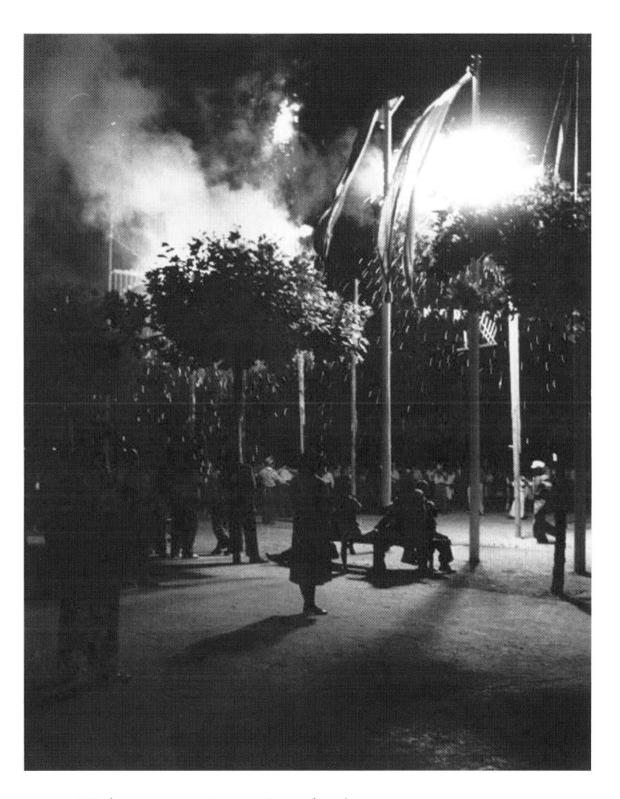

Night time activities at Pamplona's
festival of San Fennin are less solemn...

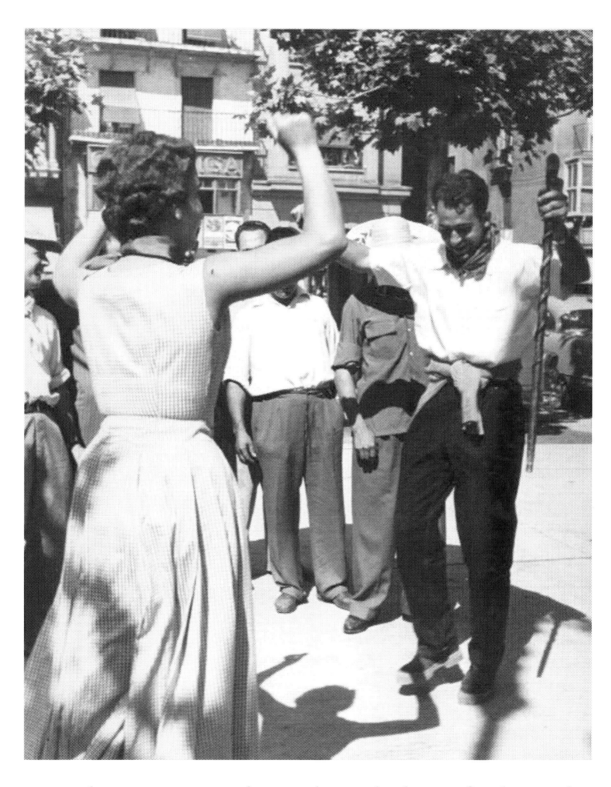

...and impromptu street dancing during the day typifies the mood.

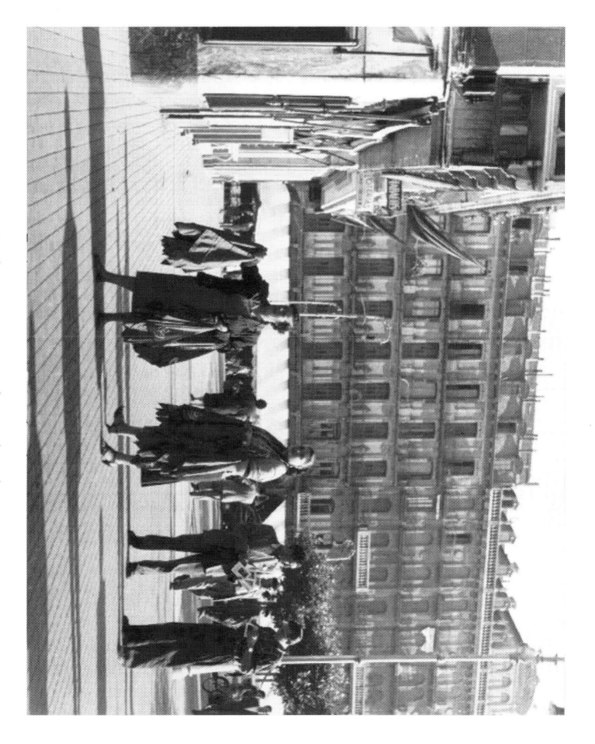

Red scarves are traditional garb…

121

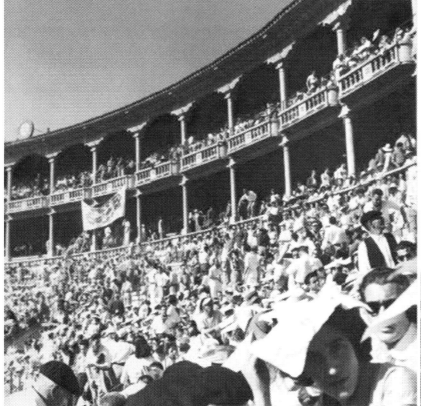

...bullfighting is

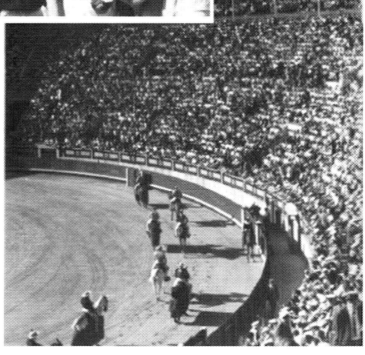

...the high point of
the festival...

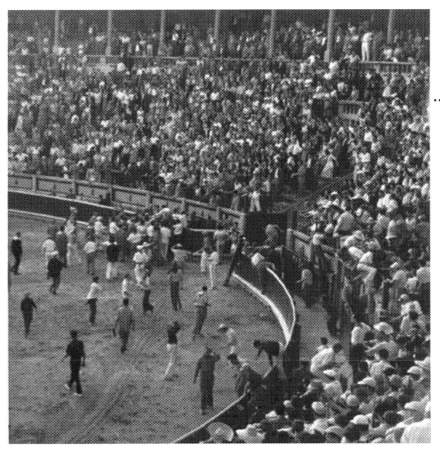

...and running with
the bulls is a
public event

...before the
professionals
enter the ring.

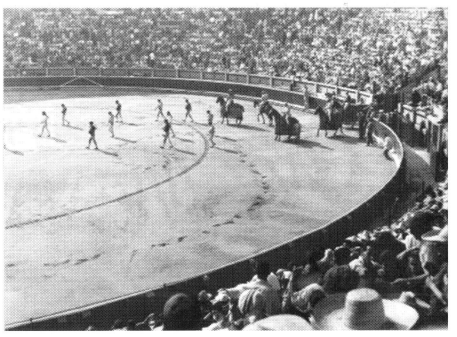

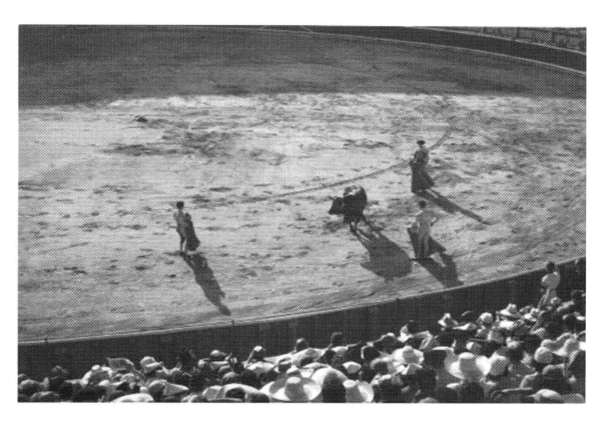

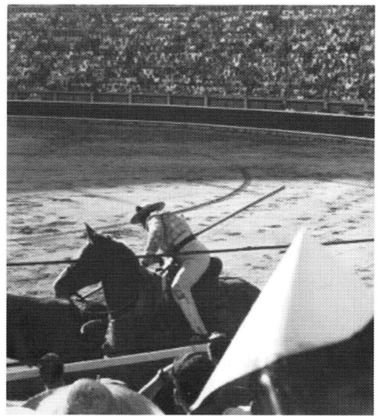

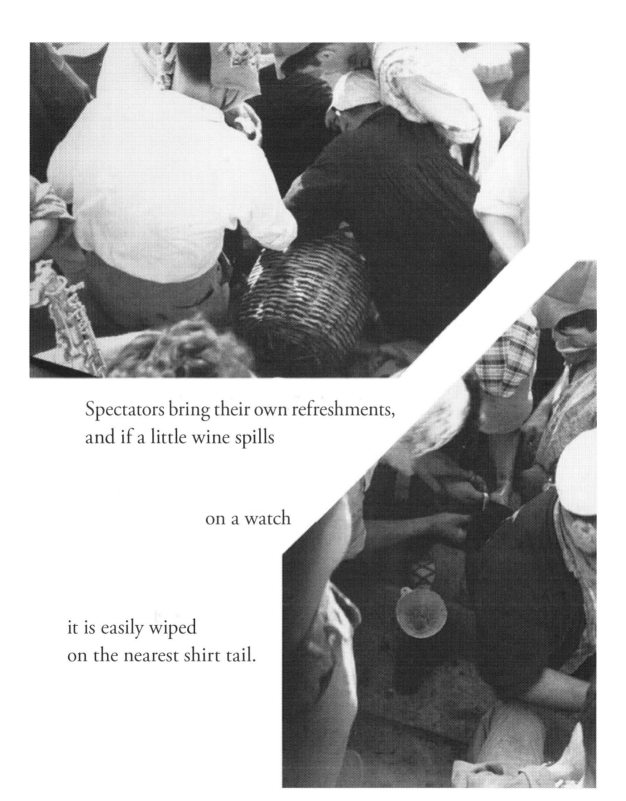

Spectators bring their own refreshments,
and if a little wine spills

 on a watch

it is easily wiped
on the nearest shirt tail.

There is always a place for casual cleaning up.

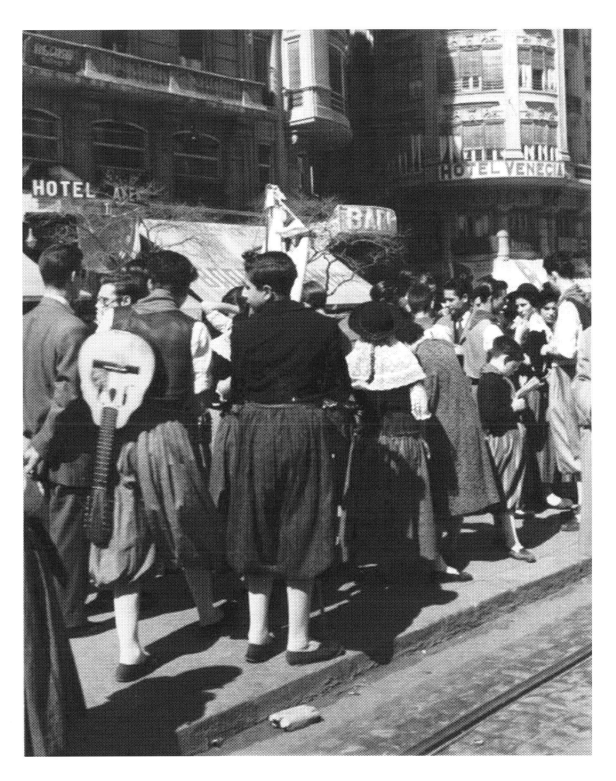

One of the most colorful festivals
is that of Saint Joseph in Valencia.

It is noted for its unique fallas-
giant papier-mache
creations at every intersection

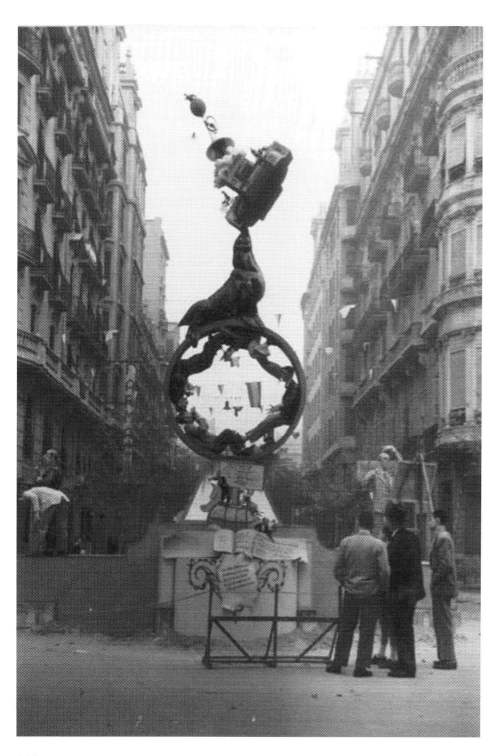

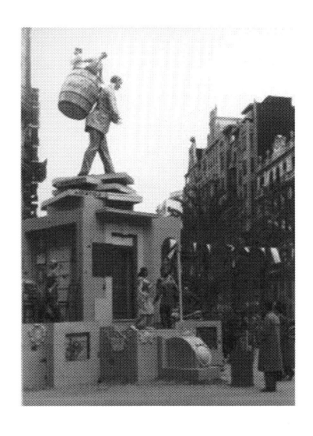

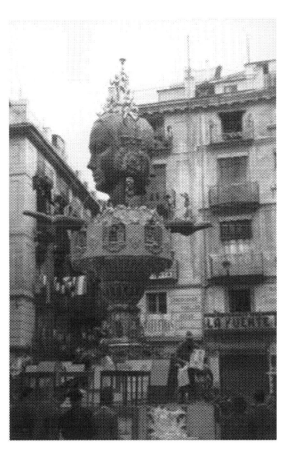

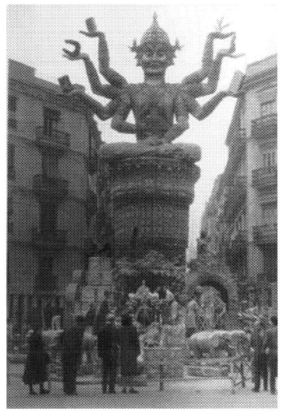

Each fella expresses a theme,
usually satirical.

As in all festivals there are parades…

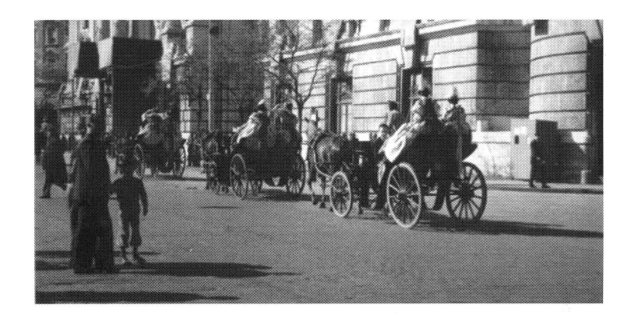

...and colorful costumes.

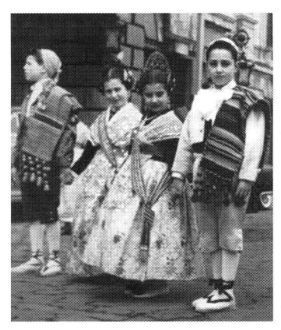

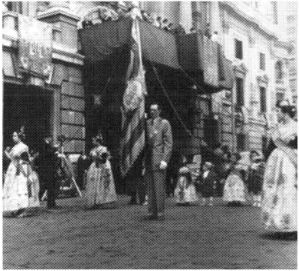

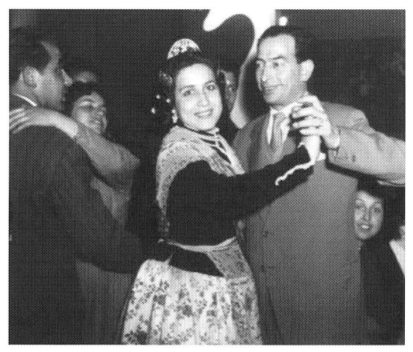

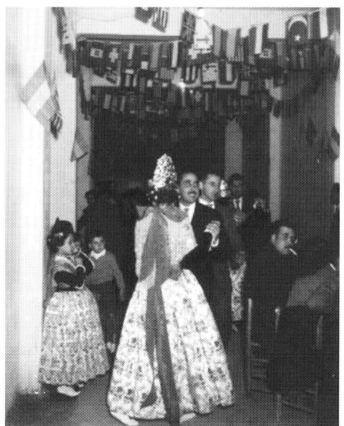

The nights are as festive
as the days...

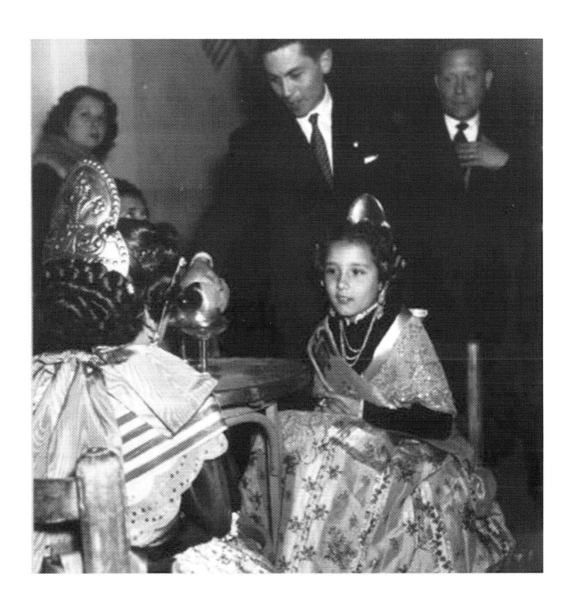

…for young and old alike.

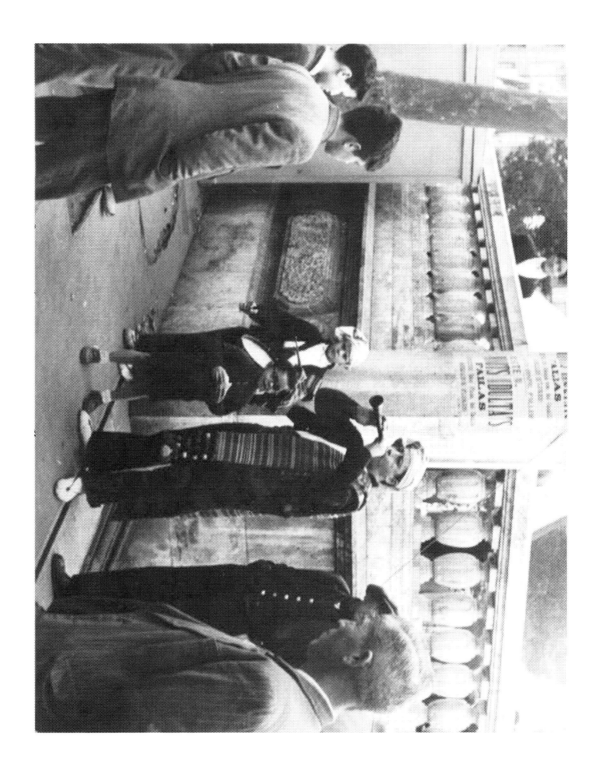

134

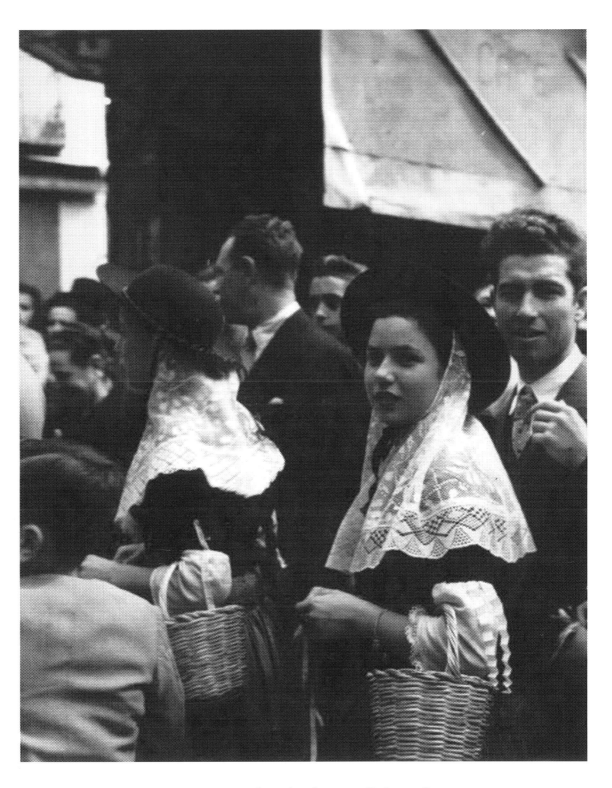

Young provincial girls show off their finery…

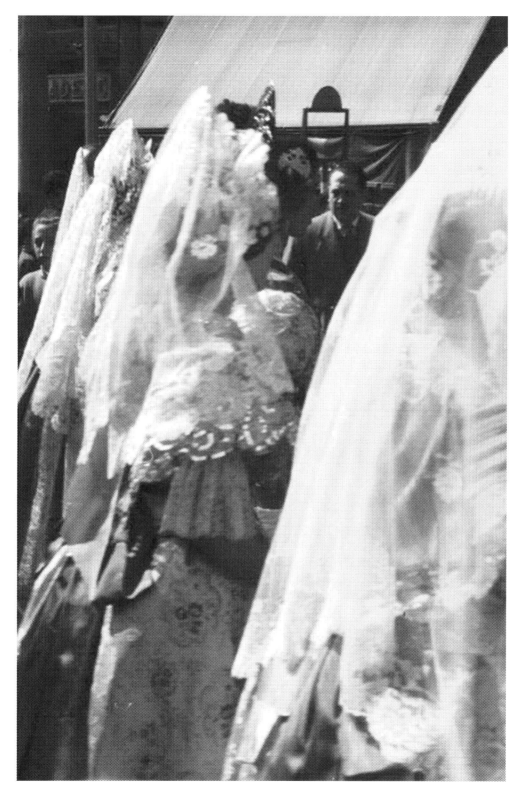

…while

…their city sisters display
mantillas so delicate that
they are transparent

Every girl dreams of being festival queen.

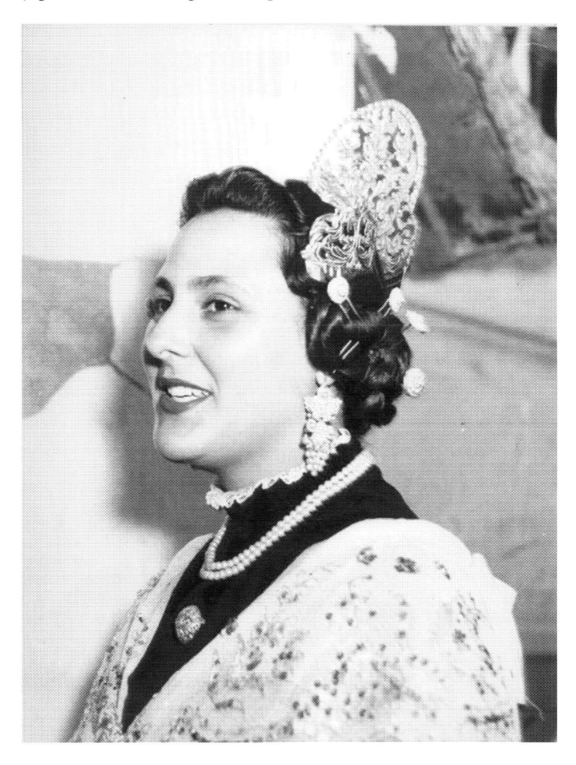

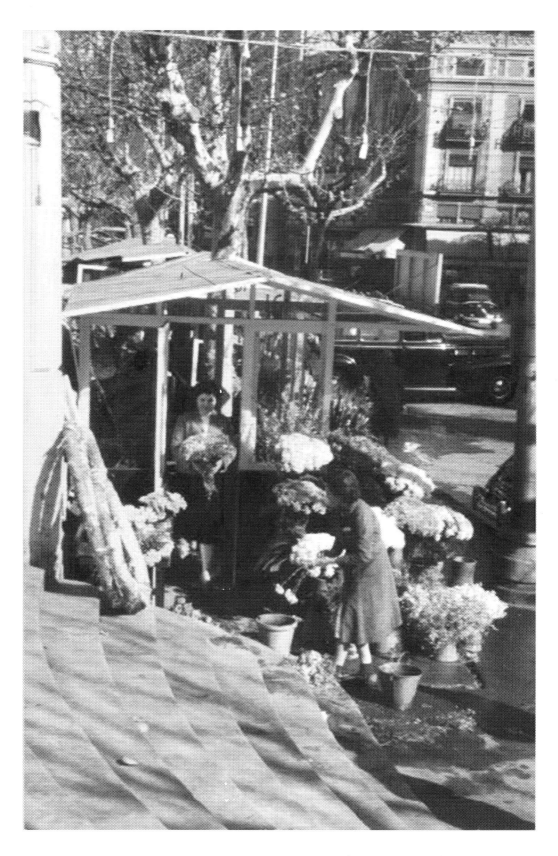

Flowers are always popular...

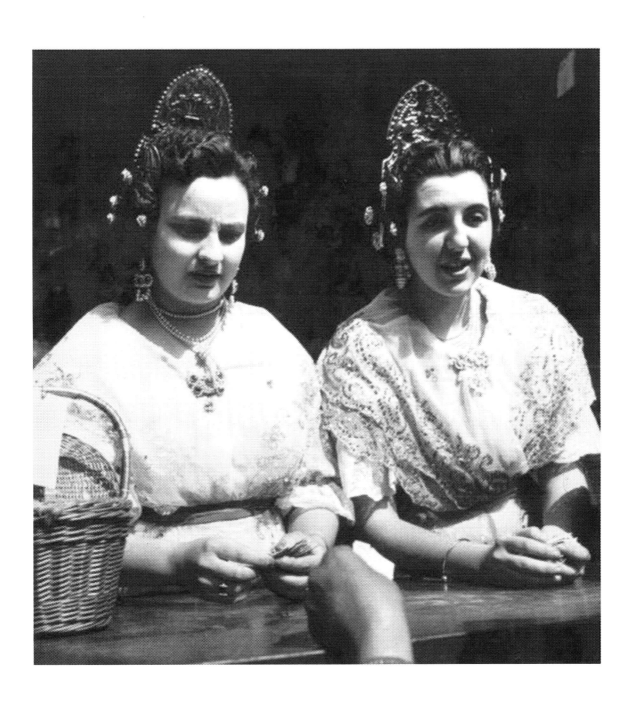

...as are lottery tickets.

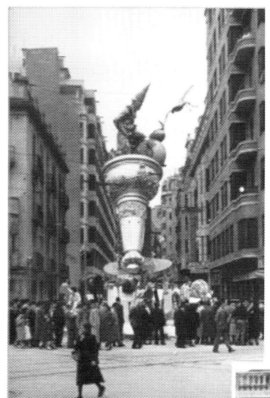

Everyone admires the fellas
throughout the city…

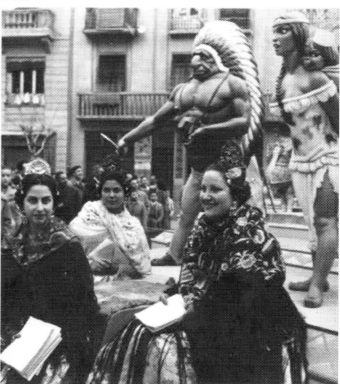

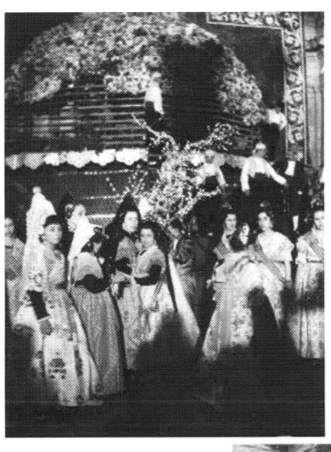

...pausing occasionally
to have pictures taken.

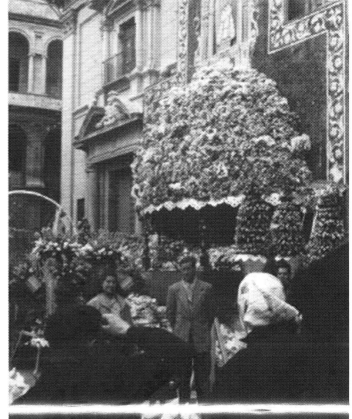

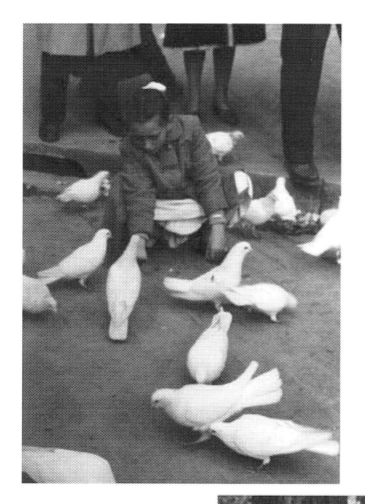

The fallas aren't the only attraction for the young

...and a water fountain is irresistible.

For tired feet there is always a place to rest.

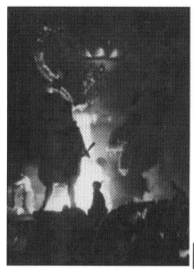

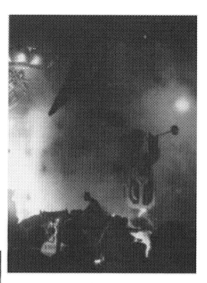

Burning…

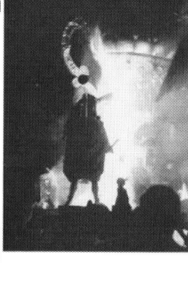

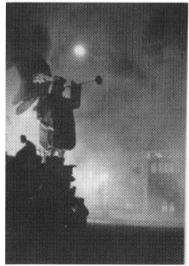

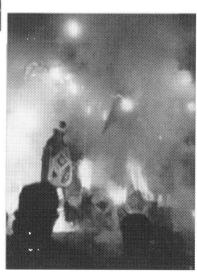

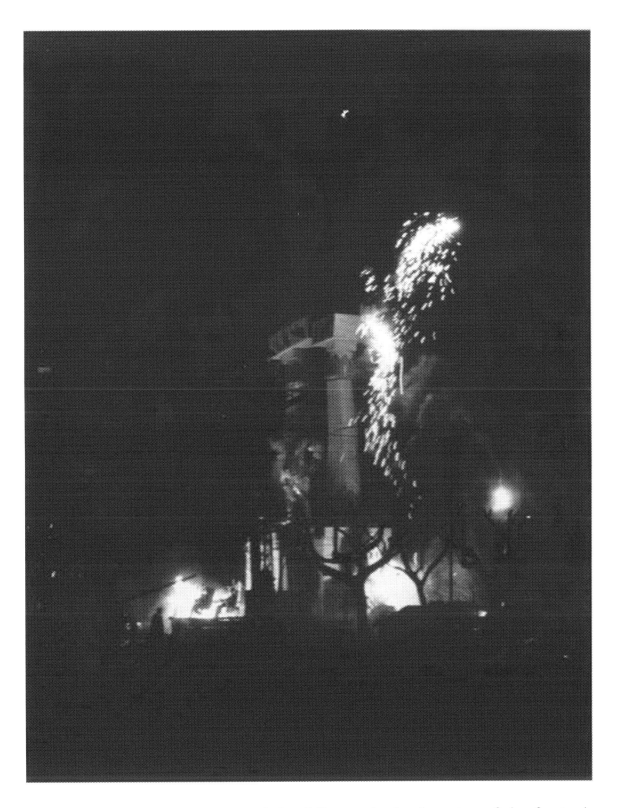

...of the fallas is the high point of the festival.

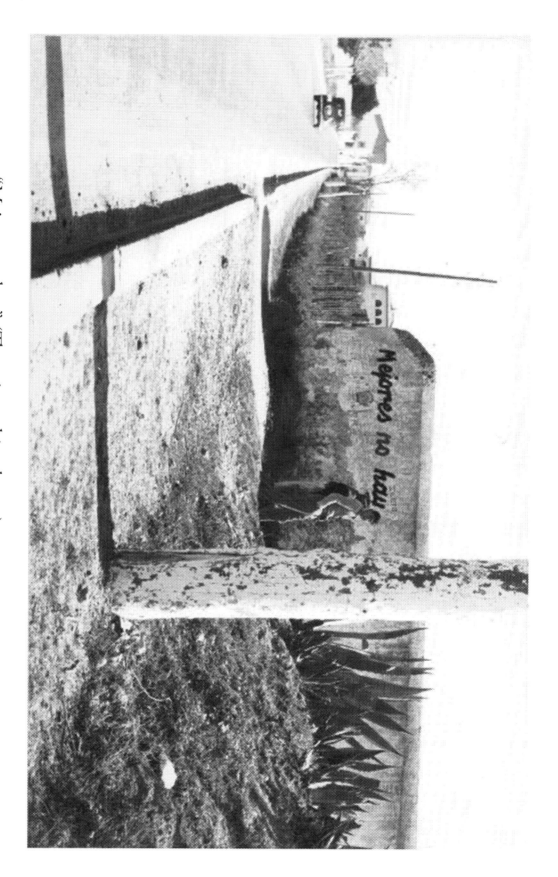

"Mejores no hay" (There is nothing better), the slogan once seen everywhere, is seldom found today

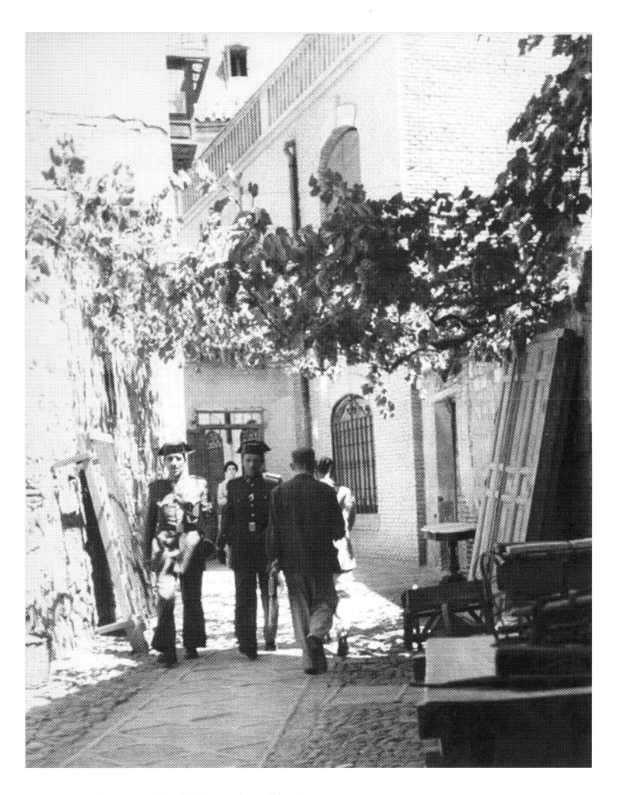

Fewer Civil Guard walk the streets.
Spain constantly changes.

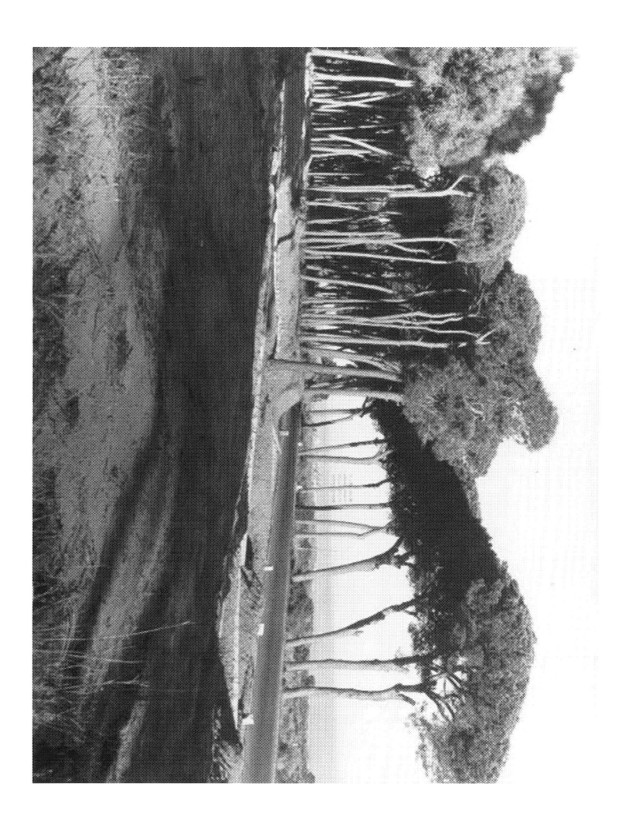

...as do the people.